Watercolour Interpretations

JOHN BLOCKLEY

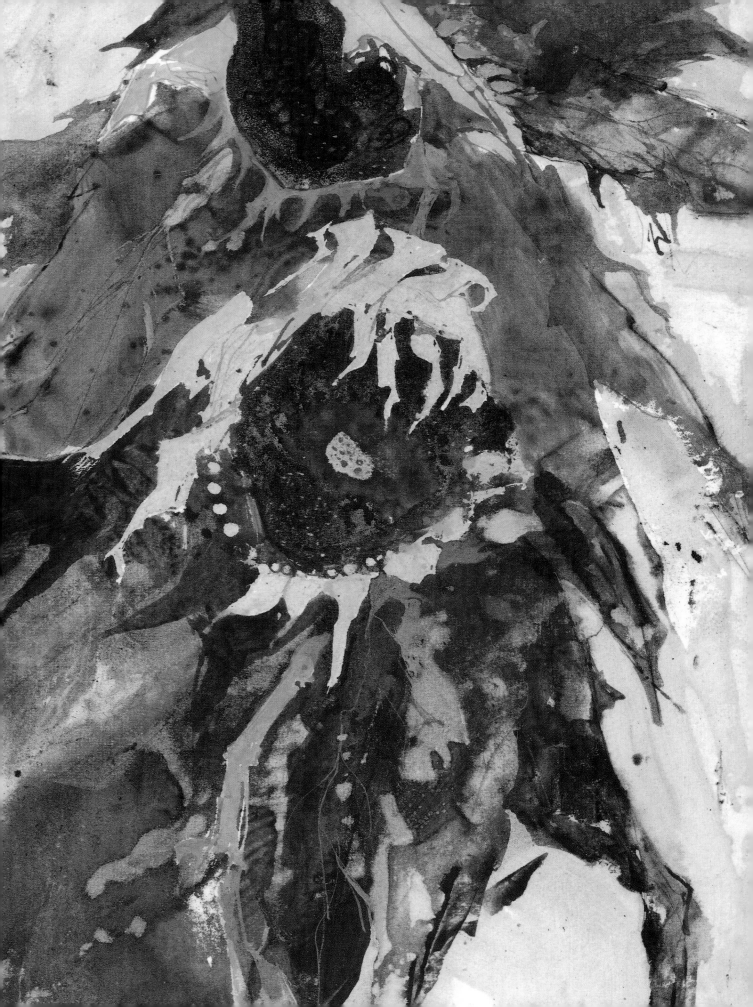

Watercolour Interpretations

JOHN BLOCKLEY

COLLINS

First published in 1987 by
William Collins Sons & Co., Ltd
London · Glasgow · Sydney · Auckland · Toronto
Johannesburg

© John Blockley 1987

British Library Cataloguing in Publication Data
Blockley, John
Watercolour interpretations.
1. Watercolour painting—Technique
I. Title
751.42′2 ND2420

ISBN 0 00 412107 4

Set in Novarese
by V & M Graphics Ltd, Aylesbury, Bucks
Originated, printed and bound in Singapore
by Tien Wah Press Ltd

Photographic acknowledgements
Colour photography by Ben Bennett
(pp. 16, 17, 18, 36, 39, 42, 43, 73, 78, 87,
111 and 152); Dr David Ridge (pp. 15, 106,
128, 132, 134, 138, 139, 154 and 156); and
Michael Petts (pp. 13, 14, 33, 107, 110,
130, 158 and 159)

Contents

INTRODUCTION 7

WATERCOLOUR MARKS 8

MOUNTAINS
Blue Mountain, Scotland 12
Sutherland, Scotland 16

TREES
'Tree Marks' 22
Summer Trees 25
Winter Trees 26
Hinchwick Wood 32

FLOWERS
Sunflowers 34
Vase of Flowers 40

BUILDINGS
Tewkesbury, Gloucestershire 44
Black Dog, London 48
Hand and Racquet, London 50
'Do It Yourself' Shop, London 56
Warehouse, London 58
St James's Palace, London 62

INDUSTRIAL LANDSCAPES
Blaenau–Ffestiniog, North Wales 66
Big Pit, South Wales 72
Marine Colliery, South Wales 76
Miners' Cottages 81

FIGURES
Miners 82
Shoppers 84
Woman with Shopping Basket 87
Gypsies 88

BOATS AND HARBOURS
Fishing Boat 92
Polperro, Cornwall 96

SEASCAPES
Scurdie Ness, Scotland 102
Seascape 105
Dunnet Head, Scotland 106
Pembrokeshire Headland,
South Wales 108

LANDSCAPES
Trefelli, South Wales 114
Tretio, South Wales 120
Pembrokeshire Cottage,
South Wales 126
Cae Lem, South Wales 130
Welsh Cottage 134
Holyhead Mountain, North Wales 136
Strumble Farmhouse,
South Wales 138
Cotswold Landscape 140

FARM BUILDINGS
Lake District Barn 142
Gloucestershire Barn 144
Farm on Dartmoor, Devon 146
Dartmoor Wall 148
Pembrokeshire Farm Buildings 150

SKY
Soft Morning 152
Storm Clouds 153
Caithness Sky 154

MOORLAND
Moorland Road 156

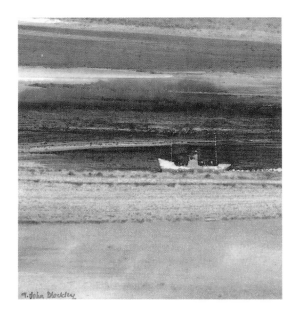
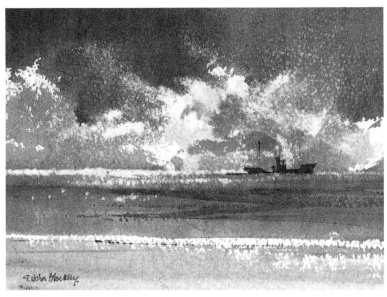
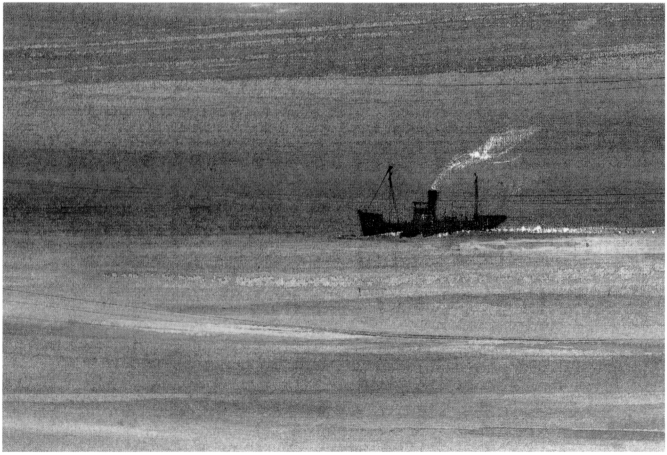

Coastal Steamer: three interpretations

Introduction

'A picture is first of all a product of the artist's imagination; it must never be a copy.' Degas

We are constantly told that the process of painting should be concerned with more than merely reproducing appearances, but the difficulty for some artists is in deciding how far to depart from the subject before them. For my part, I like to associate closely with the things I paint, so that they no longer have separate, remote identities, and consequently my paintings rarely depart fundamentally from the subject. The departures that I do make are concerned with expressing some particular aspect of a lighting condition, such as mood, seen at one moment of time; or with some quality inherent in the subject, such as its texture or shape. I regard this as a selective process in which to explore a particular emphasis and not as an alteration of the subject's basic content.

It seems to me that in order to identify closely with the subject you are painting, you must explore it in some depth and look at the possibilities of painting it differently. *Watercolour Interpretations* is all about pursuing such possibilities, and throughout you will find paintings of the same or similar subjects grouped together, with a realistic, representational version placed alongside more 'alternative', imaginative interpretations. One of the most important aspects of creative watercolour painting is the way in which an artist observes his subject. Every element of a composition – light, colour, texture and design – must be very carefully considered, for the relative emphasis the artist gives to each of these determines the overall mood and impact of his finished painting. By considering the effects of various interpretations of a subject and becoming more aware of the possibilities available, we can learn to look at it in a wider context and consequently be more experimental in our watercolour painting.

Sometimes these possibilities, or ideas, develop during the course of a painting, with changes occurring quickly and one idea prompting another, to be either accepted or rejected. On other occasions, an idea might develop over a period of time, experimentally and with a succession of failures. For me, the most exciting ideas develop from something actually seen, perhaps unexpectedly, such as grass reflecting the sky, so that the green inclines towards blue or, with a little imagination, towards turquoise. This sudden recognition that grass could indeed be blue can prompt a series of comparisons. In the book I have painted trees with conventional colours and then explored the possibilities of fantasy colours: for example, trees illuminated by silvery light in an environment of blue – perhaps even peacock blue!

Such comparisons might lead to a complete change of direction in an artist's thinking. My natural inclination has always been to paint with strong tonal contrasts and aggressive textures, but now I am also interested in different colour and tonal ranges. Mountains once seen as black and inky are now often pale blue, traced with veins of blue or pink, so that my painting vocabulary contains interpretations sometimes strong and contrasting, and sometimes on a lighter, more sensitive scale. I have found that green, the painter's nightmare colour, can be a mouth-watering colour when diffused with subtle variations of other high-key colours.

The chain reaction continues with the lighter scale of tonal and colour values, leading to a change of painting surfaces. Textures are less coarse; they become discreetly mottled with flecks of light, or with passages of light which are almost imperceptible, washed out at nail-biting, critical stages of the drying period. In turn, this change leads to a search for unfamiliar paper surfaces, smooth instead of rough, and less absorbent, so that washes of colour remain floating on the surface, allowing time for subtle adjustment and manipulation.

The process of extending one's imagination to produce interpretations of similar subjects is exciting in itself, but it is also self-perpetuating, with one discovery leading to another and resulting in changes of direction and inquiry into long-held beliefs. In *Watercolour Interpretations* my aim is to share these changes of painting style with you. Obviously, the paintings in this book, and the processes used to create them, reflect my personal thinking; but I hope that, by their example, they will stimulate your own artistic perceptions and encourage you to be more imaginative and adventurous in your painting. Every painter, at whatever level, needs to be constantly on the look-out for new inspiration and I hope this book will serve that need.

Watercolour Marks

Before looking at the paintings in this book it might be useful to discuss the kinds of brushwork, or brush 'marks', that I employed in painting them. I use traditional watercolour techniques, but adapted to express more effectively the 'marks' that I see in the landscape – the smudges, dots, lines, blots, soft-edged darks, soft-edged lights, infiltrating colours, and so on. In these instances, preliminary washes of colour are first applied and then the 'marks' are made into these at varying stages of their drying period. Different effects can be achieved in this way, depending on whether the wash is dry, nearly dry or still wet.

The darker marks are made by adding paint. Washes and areas requiring broad treatment are usually put in with a brush, whereas lines can be effectively added with a pointed stick. Pens, dipped in watercolour, may be used for finer lines and adding detail. Smudges of colour are perhaps best obtained by using a finger.

The lighter marks are made by blotting colour, using any kind of absorbent material, or by washing it away – in fact, I spend as much time removing paint as I do adding it! Adding and subtracting colour to obtain patterns of light and dark is a continuous process. Usually, I wash colour away by completely immersing the painting in a bath of water. The amount of colour removed depends on how dry the paint is and its consistency, and on the energy of washing. Immersion in a bath of still water, for example, will gently loosen wet paint, but if you want the paint to be further disturbed this can be achieved by stirring the water with your fingers so that it gently ripples across the painting. Sometimes I even run water forcibly into the bath water or directly onto the painting to create even greater disturbance. Gentle immersion will also loosen thick paint, which can subsequently be scraped away with any pointed tool. Dots or lines of paint can be gouged through the loosened paint without disturbing the paper surface. Lines of paint may be removed, or loosened, by dribbling water across the paint surface; or drops of water can be induced into the paint, or flicked or violently thrown into it.

These processes are very much related to the accepted brush manipulations employed in traditional watercolour painting. They are not slick tricks for quick effect. Mostly, they are done with great caution, teasing colour away gently in some parts of a painting and accelerating the washing away in others with intense concentration in order to achieve a satisfactory washed-out pattern, or a 'sensitive' edge value which is not too hard, not too soft, but finely balanced.

An even more unusual technique can be used with thickly applied paint. Because it sometimes stays moist longer than thinly applied paint, it can be hosed away to leave areas of white paper. To achieve this I draw patterns or dots of thick paint which, because of its extra substance, appears darker than thin, dilute colour. Then I wash it away with a hose – it is fascinating to see the white shapes appear, revealing a reverse pattern of light and dark. The darker, thicker painted shapes revert to areas of white paper, or nearly white, according to the staining power of the paint.

Timing for this technique is vital – a moment too long and a pleasing pattern will be lost. It is something of a hit and miss process, although with practice good judgement can be developed and an awareness of how the paint will behave.

By using these brush marks beguiling nuances of colour, tone and edge values true to nature can be obtained – softly diffused forms and lines, strengthening in parts then softening again to make hardly perceptible marks. Dots and dabs of paint of varying intensity set up points of tension, momentarily holding attention then becoming sinuous, lethargic lines of movement all designed to thread through the surface of the painting, not specific in their intention but inviting inquiry – hinting, suggesting, then explaining.

The illustrations on the following three pages demonstrate some of the effects which can be achieved by these techniques.

1 This started with a wash of blue over the paper. When the wet shine began to disappear, I blotted colour away with a piece of stick wrapped in cloth. The process produced soft-edged light shapes.

2, 3 These were both produced by flicking and dribbling water through a drying wash. I then accelerated the drying with a hair dryer: the initial wash dried quickly, but the added water remained wet. I washed this away to recover the white paper as soft-edged shapes. The white lines were obtained by scraping away paint which was not quite dry, but still at the sticky stage.

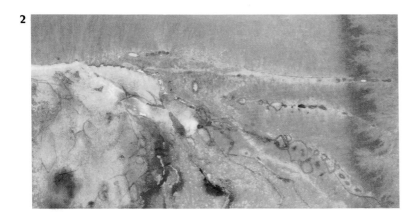

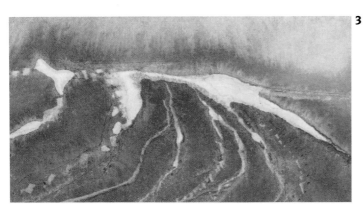

4 Again, as in the previous example, I created uneven drying by adding water. I also added stronger, darker colour in places, brushing or dotting it in. Then I washed away the light parts.

5

5 The dots here were removed either with my finger or a paintbrush handle wrapped in a rag. Varying degrees of softness can be obtained by blotting with a rag, blotting paper or newspaper.

7

6

8

7, 8 Here I made pen lines of watercolour into a damp wash. The smudgy blobs were made by dotting paint into the damp wash with a brush handle.

6 To create this effect I splashed clean water onto the paper at random and then made lines with watercolour and an ordinary dip pen. The lines are firm on the dry paper but bleed into the wet parts.

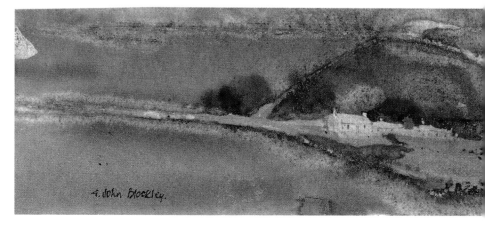

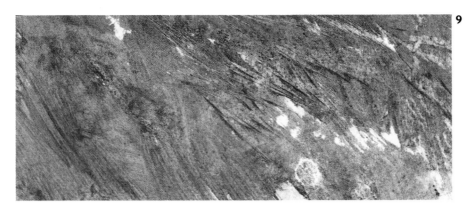

9 These vigorous diagonal brush strokes were made with a housepainter's brush into damp paper.

10 Here I used a combination of diagonal brush strokes, dabs and discreet finger smudging into a damp wash.

11 These paint textures were also made with a housepainter's brush and smudges of paint, but with additional slabs of dilute paint spread with a small painting knife.

Grey Landscape

This watercolour sketch was done using many of the processes just described. It contains passages of light suggesting walls and landscape textures, all with edges of varying softness. The only really hard edge is along the roofline of the buildings and this helps to focus attention on them. All the light shapes, including the building, were achieved by washing out or blotting away colour.

When the painting had dried I added extra colour to the background, shaping it crisply around the building to emphasize its hard-edged profile.

I used only two colours – Payne's Grey and Lemon Yellow. Mixed together, these colours produce a subtle grey-green which can be influenced towards grey by adding more Payne's Grey, or towards green by adding more Lemon Yellow.

80 x 290 mm (3¼ x 11½ in)

THE landscape in Sutherland, in the northern part of Scotland, is rugged, in places almost lunar, with outcrops of rock and wonderful textures. The colours are sometimes rich, peaty browns and ochres set against deep blues, with occasional streaks of pale lemon slashed across the deeper sonorous tones. At other times I have seen the colours of the same landscape transformed to pink and palest blue. It can be a land of dramatic contrasts, changing quickly from one condition to another: dark skies, deep blue, highlighting the mountain peaks one minute, then suddenly, with a momentary shift of weather, clearing and lightening so that the mountains become silhouetted darker shapes.

It is difficult to paint on the spot when colours alter so quickly – they change almost before they can be mixed in the paintbox. In these circumstances I find it better to concentrate on the lighting conditions, absorbing and noting the information in a sketchbook. I can then paint from these notes back in the studio. Alternatively, if I am determined to paint there and then, I follow the same process of soaking up the information in my mind and then paint quickly, almost without looking again at the subject, so that I can retain a particular impression and not be deviated by ever-changing conditions. This approach demands intense observation and a trained memory, but these can both be developed with practice.

I am always concerned about judging the shapes of mountains correctly. I scrupulously observe the height and slope of each peak and carefully consider any exaggerations for interpretative effect. Sometimes some exaggeration is helpful to explain characteristics peculiar to that mountain – a particular peak, for instance, or ragged edges of the mountain profile – but the mountain must remain recognizable. This vast, lonely area is covered with mountain peaks, each with its own name – evocative names in the Gaelic language – and I am fussy about drawing each distinctive profile. So I always start my paintings by deciding on the position of the profile on the paper and drawing it in pencil. This done, I then feel free to interpret the scene as I wish and to express it in terms of watercolour washes and other techniques such as drawing into the washes,

lifting and blotting, until gradually the paint surface is developed to suggest the nature of the ground as I see it.

Blue Mountain 1

Blue Mountain is my name for a particular part of the landscape near the small village of Oldshore More in Sutherland, Northern Scotland. I must admit to not having seen the place in quite these colours, but I had a fanciful notion to try painting it in pale blue with hints of green verging on turquoise. I am not certain, in retrospect, what prompted this choice of colours. The painting was made in the studio, from sketch notes, and in these circumstances, away from the scene, one's imagination can often lead to a new approach or stimulate inventiveness. This is not always successful, sometimes appearing a bit forced or gimmicky; but artists always hope for a bit of magic, so it is worth experimenting a little.

I do recall, however, seeing the mountain slope in cool light so that the bent grasses reflected silvery blue in places; possibly this momentary effect, once seen, was enough to suggest the colour combination. The landscape here is punctured by rounded rocks and scattered with stones, small and large. I have seen these stones reflecting an almost silvery light, and the boundary walls, too, thread silver across the hillside – soft edges with glints of light.

In the painting shown here I have tried to suggest these effects by washing dilute Phthalo Blue, and touches of Phthalo Green, over Hot-pressed paper. This paper has a smooth surface which is not easy to handle, but it is capable of producing delightful nuances of colour and the kind of marbled effect that I have seen, or imagined, in this particular area. The stones and walls were obtained by splashing droplets of water into the drying washes, which were then dried, unevenly, with a hair dryer. I washed out small particles of light and also in places some large patches, leaving the paper just slightly stained. Here and there I drew lines of watercolour with an ordinary dip pen, meandering over the paper surface; or I drew around washed-out spots to re-establish their shape slightly. Mostly the lines were added while the paper was still just damp.

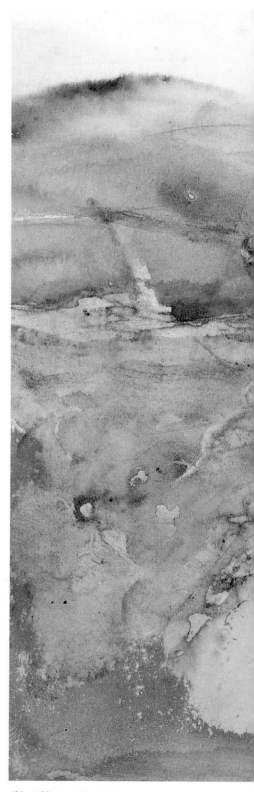

480 x 635 mm (19 x 25 in)

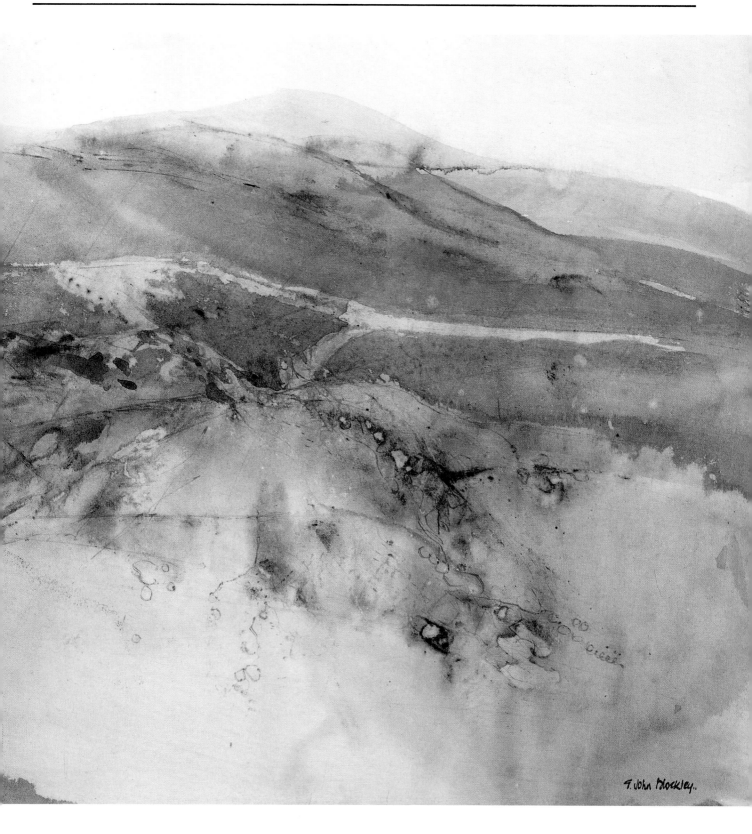

T. John Blockley.

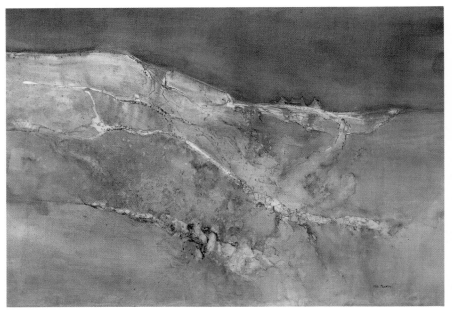

480 x 650 mm (19 x 25½ in)

Blue Mountain 2

This painting was planned in a similar
way to the previous one. It is also
painted in tones of blue and employs the
same processes of blotting, washing
away colour, and drawing lines with a
pen and watercolour. Whereas in Blue
Mountain 1 there are some fairly large
washed-out areas, particularly at the
bottom of the painting, here such areas
are much smaller. Instead of adding big
pools of water to the wash, I flicked
small droplets of water into it and then,
as the paper dried, washed them away to
obtain speckles of light.

Blue Mountain 3

This painting features the cluster of
cottages shown in the painting above. I
liked the simple shape of the end of the
white cottage facing out over the hillside.
I kept the sky as a flat Indigo wash as a
contrast to the busy, decorative treat-
ment of the foreground. Here passages
of colour were washed out, darker
colours were added, and some drawing
was done with a pen dipped in water-
colour to bring out the texture. For the
foreground colours I used mainly dilute
Crimson Alizarin added to Indigo, with
some Burnt Umber towards the left.

255 x 355 mm (10 x 14 in)

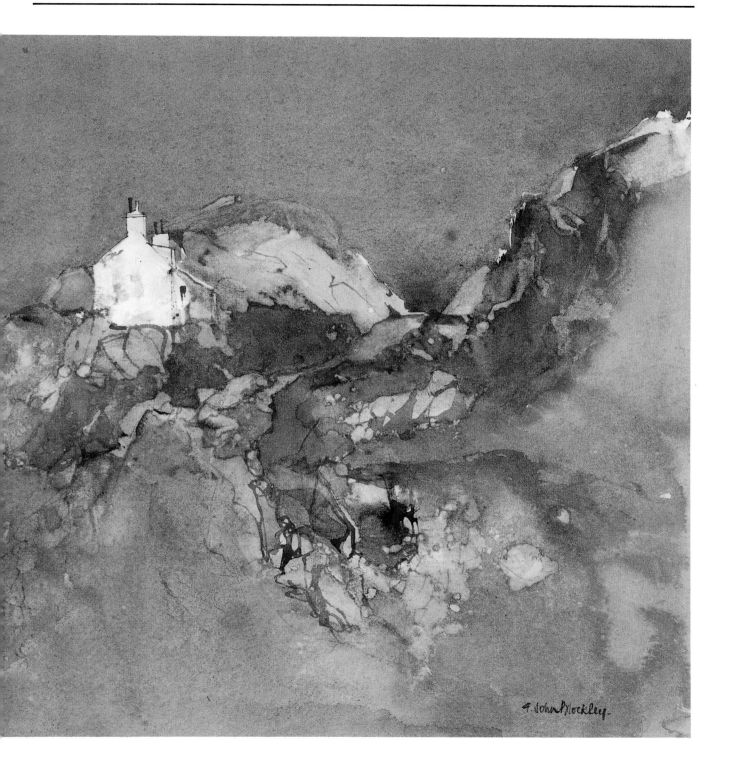

G. John Blockley.

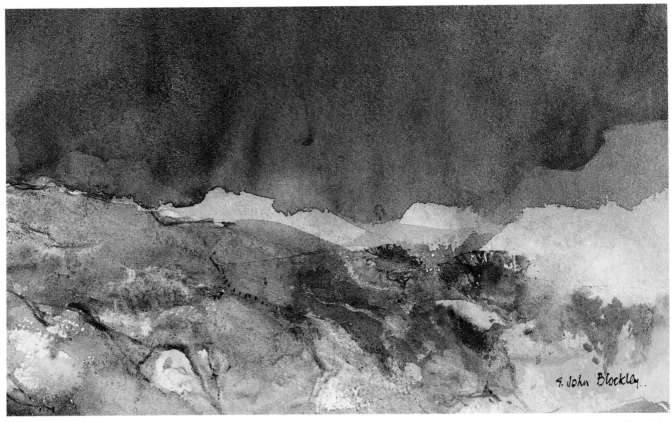

140 x 215 mm (5½ x 8½ in)

Sutherland 1

Here I was very much concerned with colour and with the balance of simple and textured areas.

Colour importance was achieved by painting in a relatively high tonal key; that is, avoiding very strong contrasts of light and dark which might detract attention from the colour. The painting was made in the studio so my choice of colours was influenced by my memory of the blue and pink that I had seen in the particular rock structures in that part of the country. Blue predominates, but is modified by washes of brown. This can be seen in the left foreground, where I commenced with a wash of Phthalo Blue, allowing it to dry completely before glazing over it with a fairly diluted, transparent wash of Burnt Umber. In the right foreground I splashed a brushful of Rose Madder to provide a colourful accent of red against the more sombre colouring of the foreground as a whole. An echoing trace of this red is also seen towards the bottom left of the painting.

To achieve a balance between the simple and textured areas I was careful not to introduce too great a difference in treatment between the foreground and the sky. The texture in the foreground is fairly restrained and the sky, though treated simply, also contains some brushwork, linking these two areas of the painting. The equilibrium is further helped by keeping the sky and foreground similar in tone. In sympathy with this treatment, I painted only indications of a few trees at the upper edge of the foreground. They contain a little brush drawing to suggest the branches and fringe of the tree tops, but they blend easily into the foreground washes.

The distant mountains are remembered as a passage of light across the landscape, just tinged with the blue of the sky. Their profile is hard and definite, but made ragged so that it is not too precisely clean-cut and assertive. This strip of light provides a focal point of interest, drawing the eye of the viewer

beyond the foreground to the distant silvery mountain range.

I tried to imagine the viewer's first reaction to a scene like this. He might instinctively look out into the distance, then look around the landscape nearer to him, but eventually be drawn back to the distance, his attention held only momentarily by individual fragments of interest. I have tried to convey this in the painting by working for a harmonious balance of tone, colour and brushwork. This harmony holds the painting together and overcomes the criticism – which is sure to come – that the painting is cut in half by the horizon. This is usually regarded, of course, as something to be avoided, but although such rules of composition are useful precautions, they are fun to challenge and overcome. It is important, however, that you find suitable means of integrating the upper and lower parts of your painting, as I have endeavoured to do here.

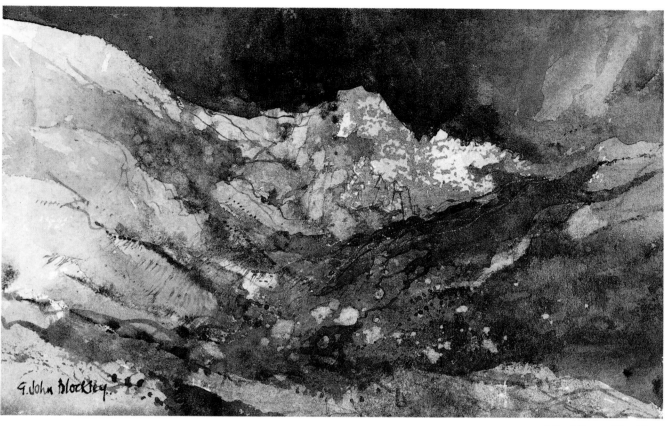

140 x 210 mm (5½ x 8¼ in)

Sutherland 2

This small painting interprets the mountains in sombre, stormy mood – conditions that I like most. On the right there is a suggestion of dark cloud – or is it mountain? We shall only know when the sky lightens. This is the excitement of the mountains – the expectancy, the waiting for confirmation of anticipated mountain peaks as they are revealed by the clearing weather.

The mountain profile starts sharp and edgy at the left of the painting, becomes slightly ragged as it curves downwards, then sharp and angular as it climbs to the peak. At this point there is a patch of light before the mountains lose themselves in the storm clouds on the right.

The central peak is mottled and crusty, and is placed against the darkest part of the sky with the purpose of attracting the eye. The rest of the painting consists mostly of broad, flat washes, with a few washed-out spots and some drawing made with a finely pointed brush and pen. The brushwork was applied vigorously, however, in keeping with the harsh, abrasive texture of the mountain subject. The painting surface is crisscrossed with lines, which although not particularly descriptive, effectively suggest the cracks and fissures of the rock surfaces.

I used few colours: Indigo and Black, painted wet into wet, in the sky and the darkest foreground parts; the same mixture, very dilute and warmed with a hint of Cadmium Red, for the light parts of the mountain; and occasionally a trace of Raw Sienna on the left to give some relief to the more sombre colours elsewhere.

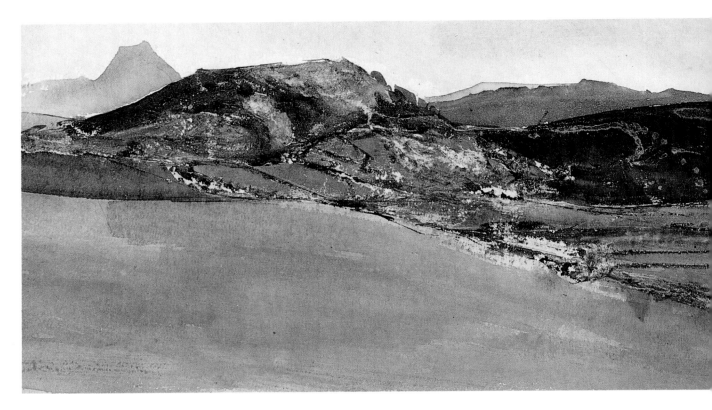

Sutherland 3

This interpretation of a Sutherland landscape was made on the spot and has not been worked on since. It was a cold day, with a near gale blowing, and I crouched in a ditch with my feet on a flat slab of stone. The ditch was man-made, cut from the peaty ground – the colour of the dark brown in the painting – and the bottom of it was covered with clear, amber-coloured water. My paper was clipped to a piece of hardboard (masonite), anchored to the ground with a stone at each end. Sometimes I start a painting on the spot but work on it only until I have obtained the essential information I need, finishing it back in the studio. On other occasions, such as this, however, the challenge of painting in almost impossible working conditions, as I used to do in my youth when I scorned working indoors, can be very stimulating.

The painting shows a panorama of distant mountains beyond a foreground of peat and bog. It is a scene typical of the area, with grass bleached to the colour of Raw Sienna, patches of chocolate brown heather covering the ground, and the whole area criss-crossed and grooved with drainage ditches. I enjoy drawing these with a pen and watercolour into wet paint; sometimes, however, as here, they can also be drawn with a pointed stick dipped into stiff watercolour which is only slightly diluted from the paintbox. When the paint is dry it can be partly removed by pouring water over it – the pressure of the water will break down the crusty paint so that only a broken, transparent stain is left on the paper. If some of the paint is resistant to the water, I break it down with my thumb, which not only helps to remove it but at the same time slightly smudges the remaining lines. As a result, the marks and striations that I see in a landscape such as this – broken lines with blobs of dark, globules of light strung across the ground like a string of

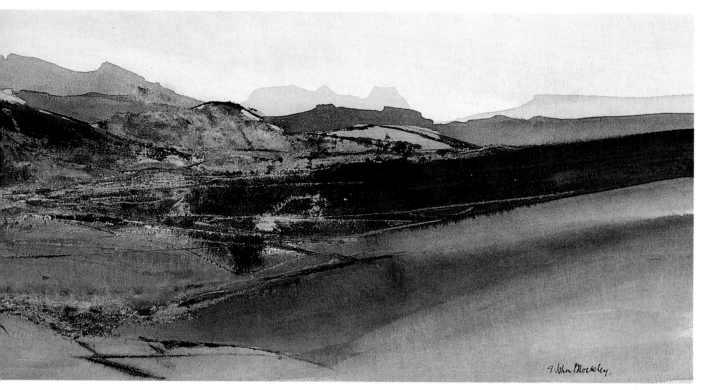

190 x 736 mm (7½ x 29 in)

beads – are very effectively portrayed.

The distant hills in this painting were drawn accurately and precisely, each curve and slope carefully defined. Being so far away, they appear as flat, pale blue shapes. The profile of the middle-distance hills is also accurate, and the colours – bronze, peat, hints of subtle pink – are true. I mixed Burnt Umber with Payne's Grey for the peat colour, Burnt Umber and Raw Sienna for the bronze, and diluted Crimson Alizarin for the pink. This analysis of the colours used is essentially correct although as I rarely wash the palette absolutely clean between washes each mixture tends to

contain something of the previous one. The pink here, for example, is slightly muted by traces of Payne's Grey.

I tried to contain all the textures to the middle distance, adding and sub-tracting colour, blotting and washing out, scratching and scraping, and drawing. I dribbled water from my water pot over the surface, and flung water at it from a big water container I keep in reserve; the painting dried quickly in the wind. In contrast, the foreground was kept simple, with just a couple of flat washes, using Raw Sienna greyed with Payne's Grey, and a little drawing. In reality the ground was heavily textured with rough heather,

but I felt the painting needed a restful area, so I concentrated the roughness elsewhere. Painting is very much concerned with the organization of rough and quiet areas, soft edges and hard-edged flat shapes. By producing an inter-esting texture in this way the artist encourages inspection, offering the viewer an invitation to read the painted surface. Whenever I paint I imagine the viewer's eye travelling over the paper, moving easily across the big simple areas, examining the busy textures, asking questions, moving on, then pausing momentarily at small precise shapes as if at a punctuation mark.

Sutherland 4

This interpretation features a lighting
condition that I have seen: blue-black sky
with rain slanting downwards and partly
obscuring the mountains, which in the
dramatic lighting appear almost silvery
and hard edged. The sky was painted as
a flat wash around the hard profile of the
mountains. Then I made positive, diago-
nal, downward strokes through the
wash with a 25 mm (1 in) housepainter's
brush, occasionally dragging the sky
colour over the white mountain shape. In
contrast to these angular lines and hard
edges, the foreground, with its warm
colouring, reds and browns, is heavily
patterned with rounded shapes. Colour
was spotted onto the surface, paint was
dribbled into wet colour, and soft-edged
rounded passages were blotted or
washed away under the tap.

 I used Indigo for the sky, Raw Sienna
for the horizontal band of yellow
immediately below the mountains, and
Brown Madder Alizarin and Indigo
painted into a first wash of Burnt Umber
for the foreground.

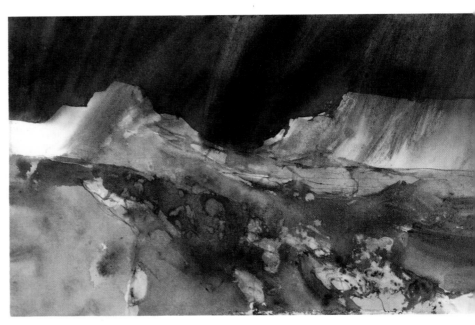

180 x 280 mm (7 x 11 in)

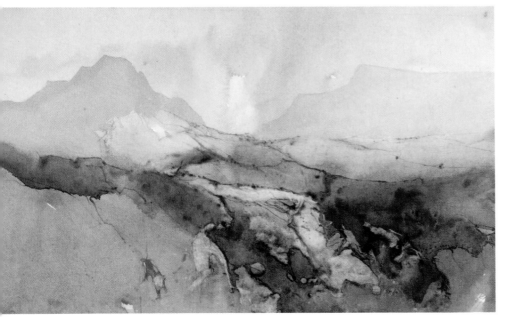

180 x 280 mm (7 x 11 in)

Sutherland 5

In this quieter interpretation the colours
are less intense and contrast is reduced.
The mountains were painted with flat,
simple washes, with all the brushwork
and texture confined to the foreground.
The light passages were blotted out, and
here and there soft lines, only just appar-
ent, drift through the painting. These
were made with a pen and watercolour
and were drawn on damp paper.
Sometimes, however, I wet the paper
more thoroughly and draw the lines on
the actual surface of the water. This is a
deliciously tantalizing process – the
gentle lowering of the tip of the pen onto
the water surface and the way the line
sometimes sinks onto the paper and
sometimes diffuses slightly into the film
of water. It sounds impossible, but
sometimes it works, and I love to try it.

 The same colours were used for this
painting as in the previous interpreta-
tion, but very much diluted.

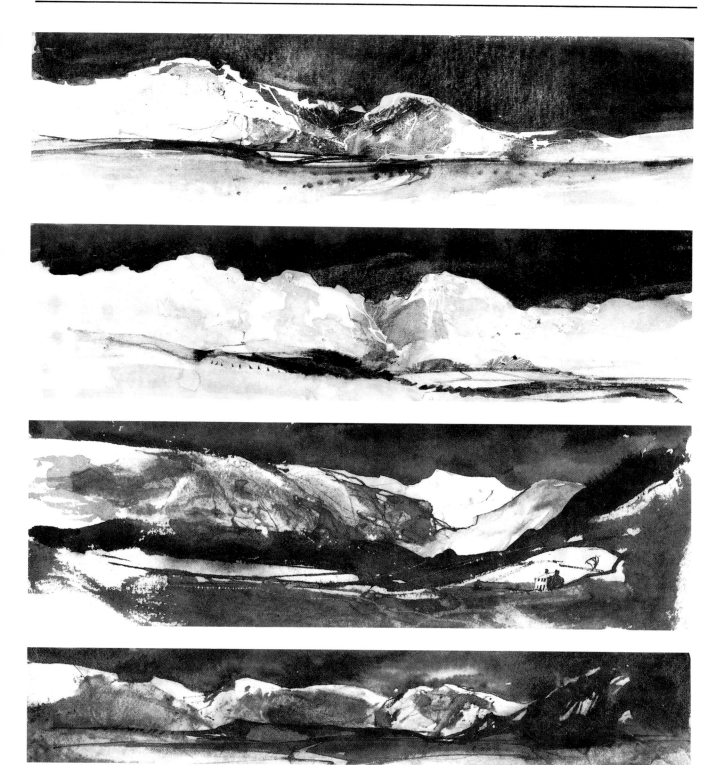

The immediacy of painting small sketches without colour is very satisfying. A few monochrome washes immediately express the contrasts of light and dark tones and can convey the textures and shapes of these dramatic mountain sketches.

'Tree Marks'

'... instead of aiming at finish, aim to execute the mental vision ... with as much inventive energy as possible.' Samuel Palmer

The following six little watercolours show interpretations of tree forms, using the processes described in the chapter on watercolour marks. They are concerned with impressions of light reflected off moving foliage or peeping through it, and are suggestions of tree structures rather than analysed and anatomically correct representations.

The light parts were obtained by first creating dry and wet areas of paint, then washing away the wet parts to leave soft-edged passages of light. The darker parts were drawn either with a brush or a brush handle dipped in paint, or by applying finger dabs and smudges into paint of varying stages of dryness.

For the bright greens I used Aureolin mixed with a very little Hooker's Green, and for the blue-greens Phthalo Blue darkened in places with Payne's Grey.

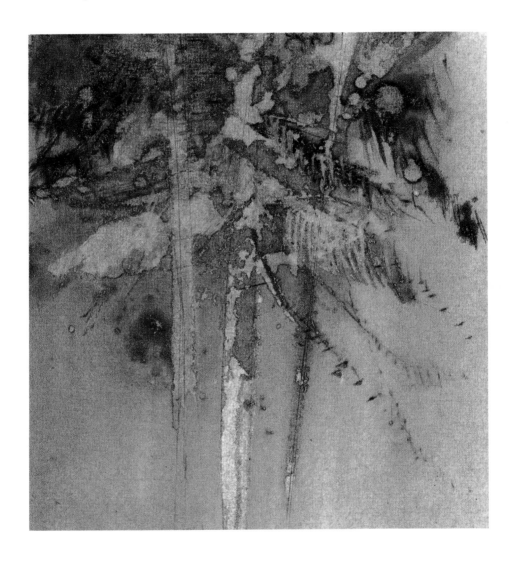

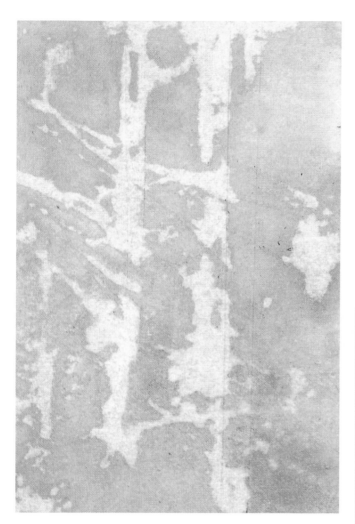

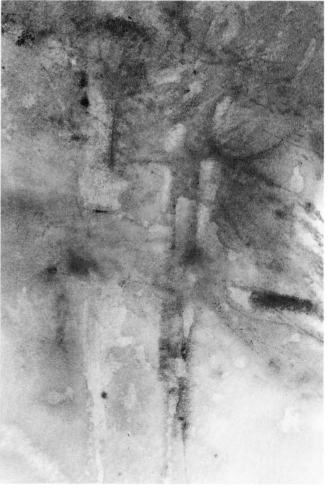

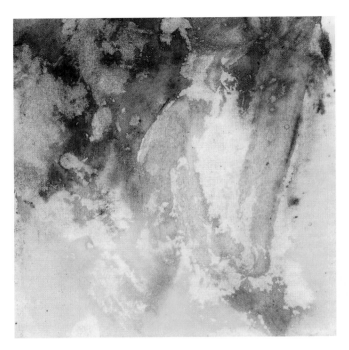

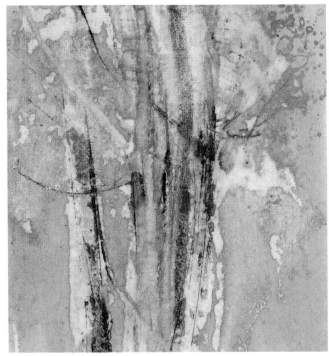

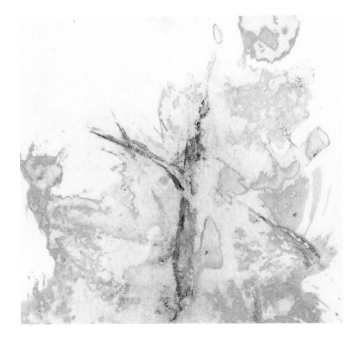

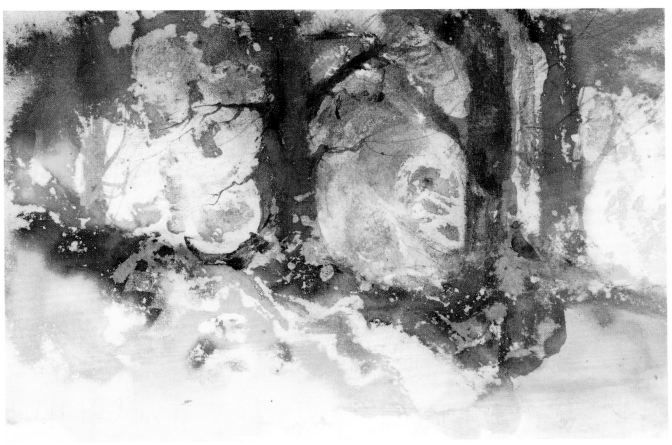

165 x 245 mm (6½ x 9¾ in)

Summer Trees

This was painted in the spirit of the previous series of small watercolour sketches. The image here is of swirling passages of light and masses of green foliage, with the leaf edges blurred and softened by the diffused light beyond. The foliage is not depicted in precise detail and is recognizable only in association with the tree trunks. In fact, most of the painting consists of abstract blotted-out shapes and random patches of colour. You can see that the foreground is painted in the same manner as the spaces between the trees; to have painted it realistically, indicating each blade of grass, would have destroyed the illusion of light.

The foliage was painted with Hooker's Green. I also used a little of this colour for the tree trunks, but in this instance I applied it directly onto the paper and brushed a strong mix of Payne's Grey into it. This mixture, with hints of Burnt Umber added, is repeated in the dark parts of the foreground around the bases of the trees.

Pencil drawing, 255 x 330 mm (10 x 13 in)

Winter Trees

The drawing here was made one after-
noon when the ground was snow-
covered and the trees black against the
sky. I worked from the relative comfort of
my car.

It is composed in two equal divisions,
the trees occupying the top half of the
picture and the foreground occupying
the lower half. This was an intentional
arrangement – I was struck by the white-
ness of the sloping ground leading up to
and supporting the line of dark trees and
so I decided to give it plenty of space in
the drawing. I was also impressed by the
height of the trees, reaching up to find

the sky, and so instead of compressing
them within the confines of the paper, I
stretched them out to disappear beyond
the top edge.

The drawing contains considered
linework combined with free, loose line:
it was important to draw the subtle,
sinuous curves of the taller tree trunks
accurately as they stretched upwards and
yet also to indicate the movement of the
thinner branches with flexible, looser
drawing.

The following four watercolour interpre-
tations are based on this drawing.

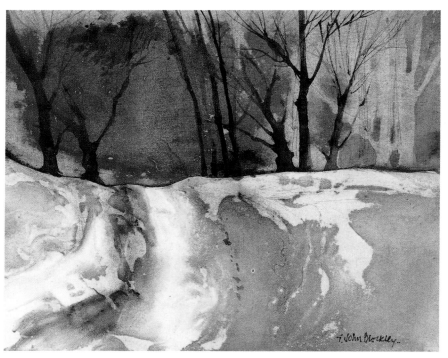

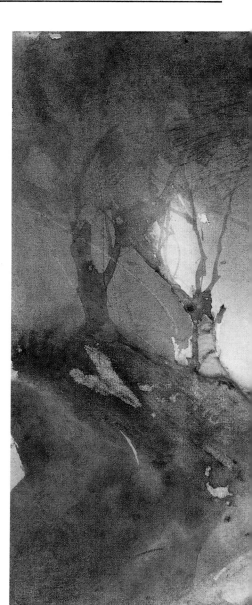

150 x 180 mm (6 x 7 in)

Winter Trees 1

I was impressed by the whiteness of the
snow and this conditioned my approach
when painting this first colour sketch. It
is a very obvious, although frequently
disregarded fact that white appears
whiter if surrounded by dark colours – so
here I darkened the sky. The whiteness of
the snow is also emphasized by reducing
the whitest part of the painting, the
paper, to only a small area. Everywhere
else, the white is in fact slightly blue. To
obtain this colour I used just a little
French Ultramarine, greyed in places
with ink.

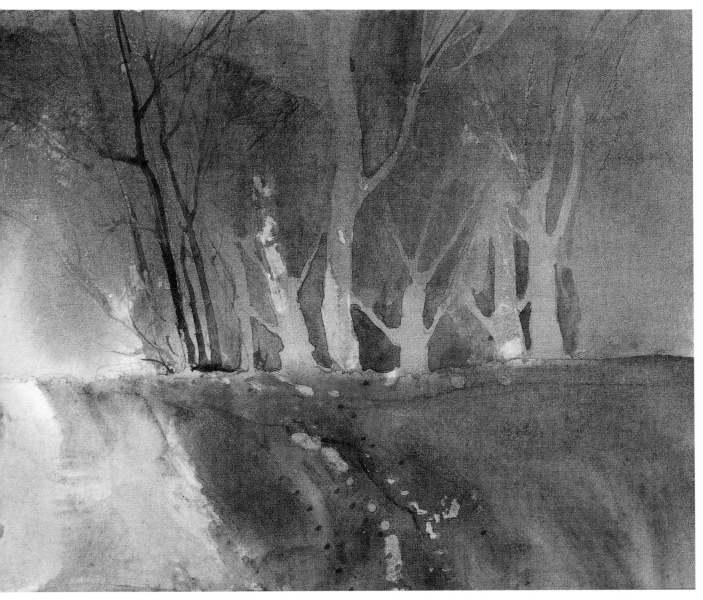

180 x 280 mm (7 x 11 in)

Winter Trees 2

In this sketch it is winter still, but
without snow. The emphasis here is on
the road, light in tone, leading through
the gap in the trees towards space and
light beyond. As a change from the
previous sketch, I made some trees
lighter, providing a counterchange of
dark, light, dark, light, across the picture.
I used a mixture of French Ultramarine
and Black, with Burnt Umber added to
this, for the foreground.

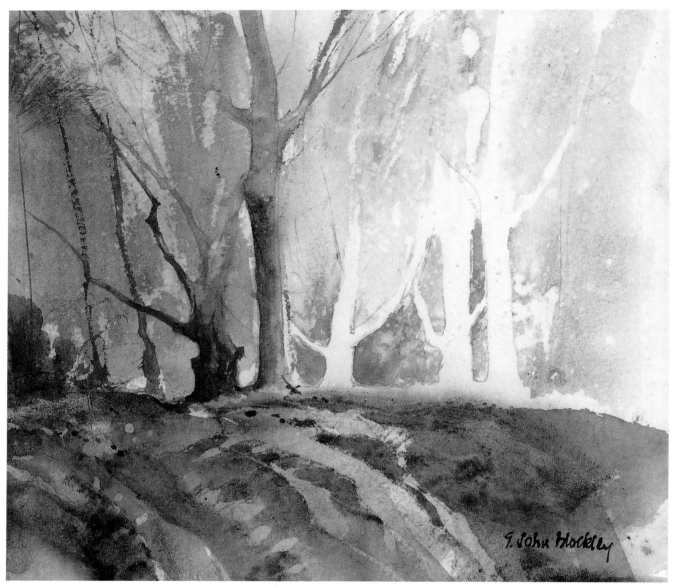

150 x 180 mm (6 x 7 in)

Winter Trees 3

This sketch, in contrast, ignores the road and concentrates on a few of the trees on the right of the drawing on pages 26 and 27. I aimed to give a sense of cool light filtering through them, so I left white paper for the distant trees on the right and blotted and lifted random dots of light from the misty blue background. I used the same colours as in the previous painting, with the addition of Cadmium Red to the mixture for the area on the left of the painting.

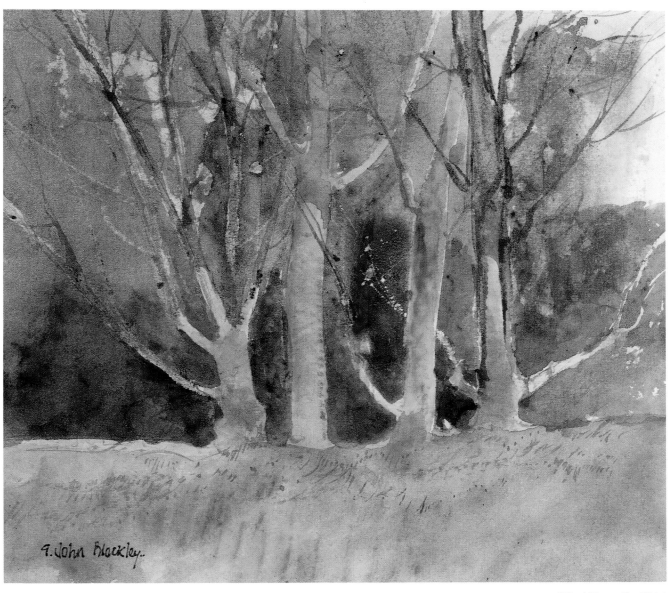

9.John Blockley.

150 x 165 mm (6 x 6½ in)

Winter Trees 4

This sketch shows a change of colour from the predominant blue of the previous ones. The green of the grass, a mixture of very dilute Phthalo Blue and a little Aureolin, is continued for the trees, which helps to give unity to the work and an impression of light falling onto the trees and grass.

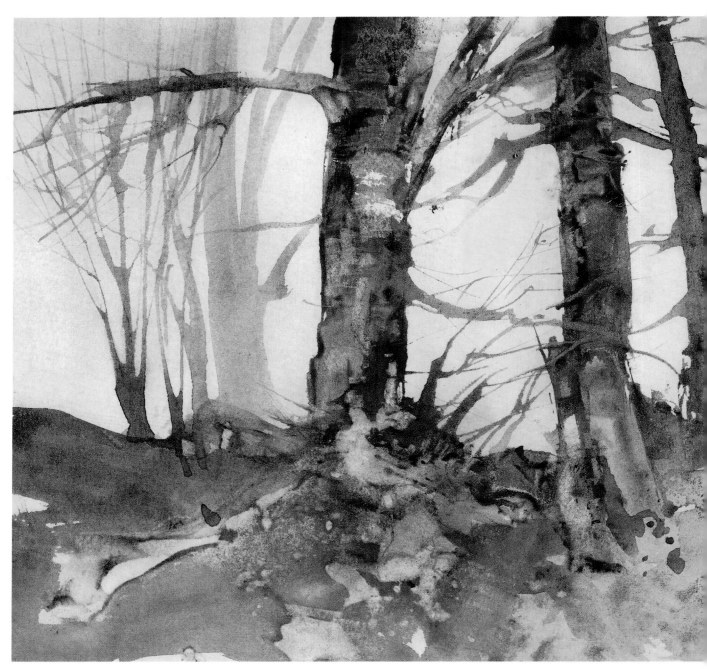

190 x 285 mm (7½ x 11¼ in)

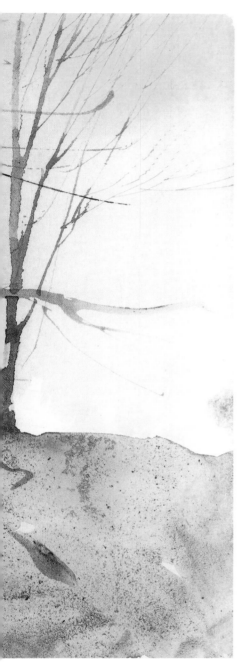

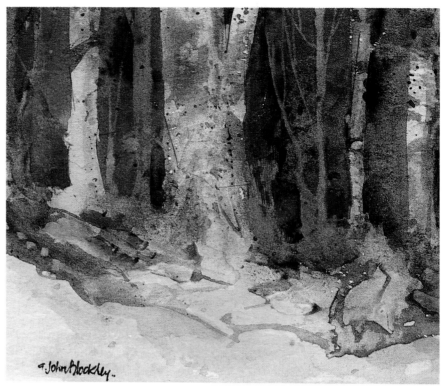

150 x 140 mm (6 x 5½ in)

Hinchwick Wood 1 (left)

The first painting shows a simple group of trees painted in a realistic way. I used Burnt Umber with varying additions of Indigo for the tree trunks and allowed the direction of the brush strokes to follow the curvature of the trunks and suggest their roundness. Some interest is provided in the foreground by using washing-out techniques. In contrast to the more detailed brushwork for the trees and foreground, the sky is a simple pink wash of dilute Cadmium Red. This colouring was sensed rather than actually seen.

Hinchwick Wood 2 (above)

The second painting also illustrates a group of trees in Hinchwick Wood but here I have given more play to an imaginative interpretation with eye-catching colour. The tree trunks are bleached to give the effect of being touched with silvery light and are set against a fantasy background of dark blue. Is such intensity of blue ever seen in a wood? Remember that my interpretation of this scene is not intended to show a literal rendering of tree colours. It is a personal adventure with colour – dark blues, traces of pale blue and passages of dark green. The green is a 'blue-green' in sympathy with the overall blue tones and the trees also contain hints of pink, repeating the pink of the foreground. This part of the painting, however, is kept simple and light. The colours used are the merest tints, only slightly staining the white paper, so that the colour intensity is localized to the background.

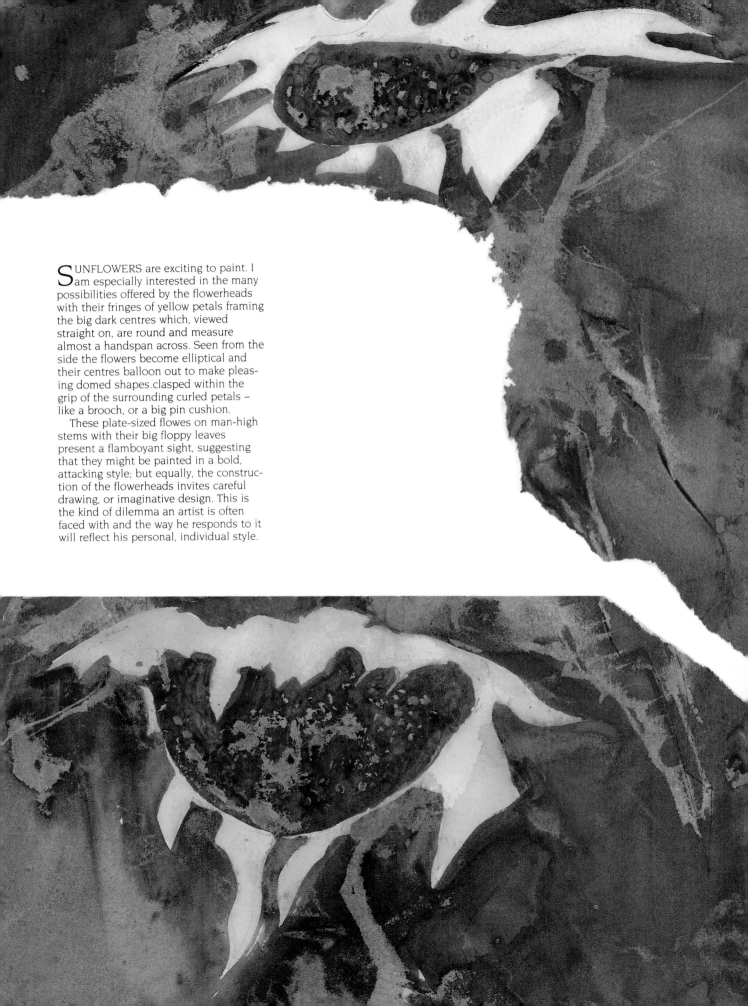

SUNFLOWERS are exciting to paint. I am especially interested in the many possibilities offered by the flowerheads with their fringes of yellow petals framing the big dark centres which, viewed straight on, are round and measure almost a handspan across. Seen from the side the flowers become elliptical and their centres balloon out to make pleasing domed shapes.clasped within the grip of the surrounding curled petals – like a brooch, or a big pin cushion.

These plate-sized flowes on man-high stems with their big floppy leaves present a flamboyant sight, suggesting that they might be painted in a bold, attacking style; but equally, the construction of the flowerheads invites careful drawing, or imaginative design. This is the kind of dilemma an artist is often faced with and the way he responds to it will reflect his personal, individual style.

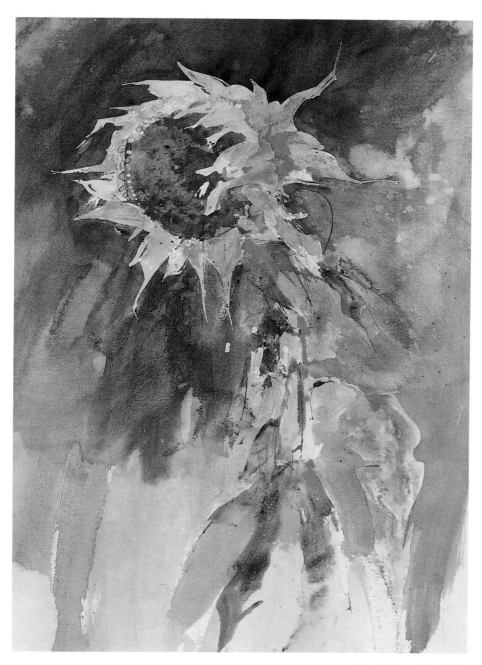

455 x 305 mm (18 x 12 in)

Sunflowers 1

This first painting shows a fairly literal approach to the subject with the flower-head carefully observed and recorded. I began by drawing the flower and the leaves in pencil and then I washed in the neutral background of Payne's Grey mixed with Burnt Umber, leaving white paper for the plant. I deliberately made the background rough and crude; it contains a few tonal changes, dark and light, to give some variety but otherwise is not specific. I used Cadmium Yellow with a little Cadmium Orange and Aureolin for the flower and, with the addition of Payne's Grey, the leaves.

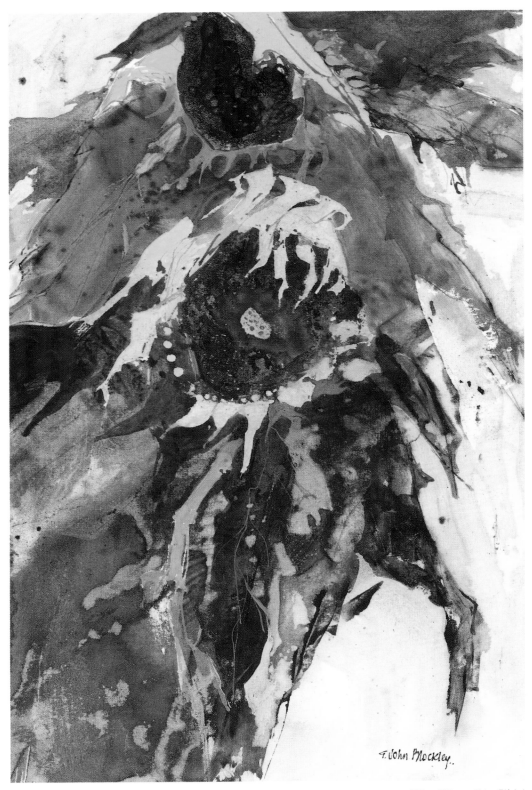

280 x 185 mm (11 x 7¼ in)

Sunflowers 2

This interpretation is still fairly literal but here I am beginning to recognize some design possibilities, exploiting them to emphasize the particular characteristics of the flowers. For example, the centre of the top flower has a less rounded, more interesting shape. As I drew its outline I imagined myself using the brush to squeeze the flower centre into an exaggerated bulging shape. The petal distribution of the smaller flower, too, is more interesting than in the first painting. I collected the petals together at the top of the flower to make two large shapes and contrasted them with petals reduced in size along the bottom edge. This change of dimension is further exaggerated by painting the larger petal shapes bright yellow, whereas the small petals are less colourful. The petals of the larger flower are brighter still so that the colour is concentrated most of all at this part of the painting. The impact this creates is further emphasized by the treatment of the petals, hard-edged, ragged and torn, and by the fact that they are against the darker tones of the flower centre and background of leaves.

As with the other flower, the petals are arranged in considered shapes. Those along the top of the flower are collected together into a large ragged fringe, whilst the lower petals are smaller, shorter, some almost rounded. The few very small round beads of yellow were added to provide interesting variation in the overall pattern of yellow. In fact, they did not actually exist, but I derived the idea of them from some hardly visible small seed pods around the periphery of the large dark centre. Well, I think they were seed pods, and I think I did see them – or perhaps I just wanted to see them. There's no reason why we shouldn't let our imagination create what we want to see. In this way a painting can evolve from being an actual representation to a more imaginative interpretation. Here the character of the flower is maintained, with its bulbous centre – dark, mottled, and with hints of bronze – surrounded by a fringe of brilliant yellow petals. These are elements of fact, which in the painting are interpreted into a distinctive design. The fringe of petals travels, anti-clockwise, from the large grouping at the top to the four precise blots. As I write I can feel the brush doing them – dot, dot, dot, dot – then putting in the group of three larger petals (though not as big as those at the top), then reverting to blots, this time much larger than before. You may wonder why I decided to include these blots. There are several reasons: they provide echoes of the big rounded flower centre; they provide a contrast with the shape of the petals; and they form part of a counter-change of dimension – large petals at the top, small dots, larger petals, then smaller blots again.

The leaves are just as I saw them, by which I mean that I did not inquire closely into the form of each one. They are painted simply as an untidy collection of leaves forming a backdrop to the flowers. They make one big ragged shape, repeating the ragged nature of the petals. This repetition of shape is more important, I feel, than painting individual leaves – the profile of the whole shape suggests these sufficiently. Within the one shape, however, colour variations of green, red and brown hint at the vulnerability of the large unsheltered plant.

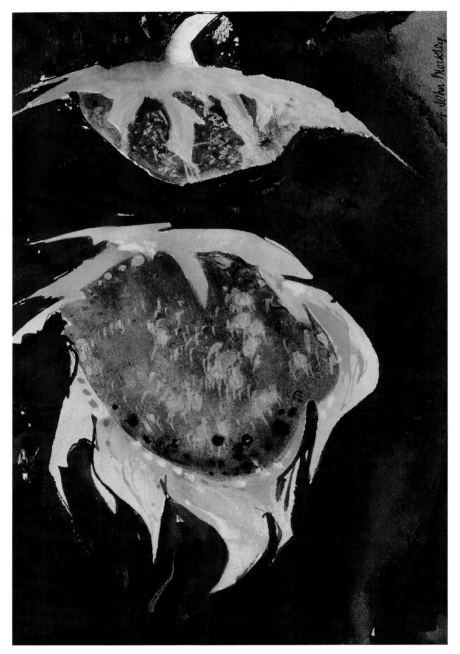

280 x 185 mm (11 x 7¼ in)

Sunflowers 4 (right)

This example is perhaps even more stylized. I reduced the size of the petals to emphasize the large flower centres, and I painted them as one continuous enclosing ring rather than separated petals.

The centres were painted blue and allowed to dry, then overpainted with fairly stiff black paint. Just before this dried, while it was still sticky, I lifted spots of colour away with a brush handle wrapped in a rag to reveal the underlying blue. Then I immediately outlined some of these blue spots with the wooden tip of a brush dipped in black paint. I tried to create an interesting distribution of light particles, carefully varying their dimensions and spacing. This process was prompted by my original analogy of a brooch, clustered with stones and granulated light.

The edge of the lower black centre is painted with subtle variations. At the top, it is crisp and hard against the yellow fringe of petals. On the right it has softened and slightly blended into the still-damp fringe, whereas on the left I contrived a change of contrast by stippling a few very small dots of black paint along the edge. I think these subtleties of edge values are important. They are sufficiently precise to enclose and contain the dark flower centre yet they do not compete with the very crisp outer edge of the yellow fringe.

Sunflowers 3

In this painting I have extracted some definite design elements from the flowers themselves. I have tried to emphasize the depth of yellow by surrounding it with black paint and by keeping the edges sharp and crisp – I felt that the intensity would be reduced if I softened the edges into the background. When the paint of the soft brown centre was still damp, I used the point of a small painting knife to flick out the suggestions of soft hairy growth.

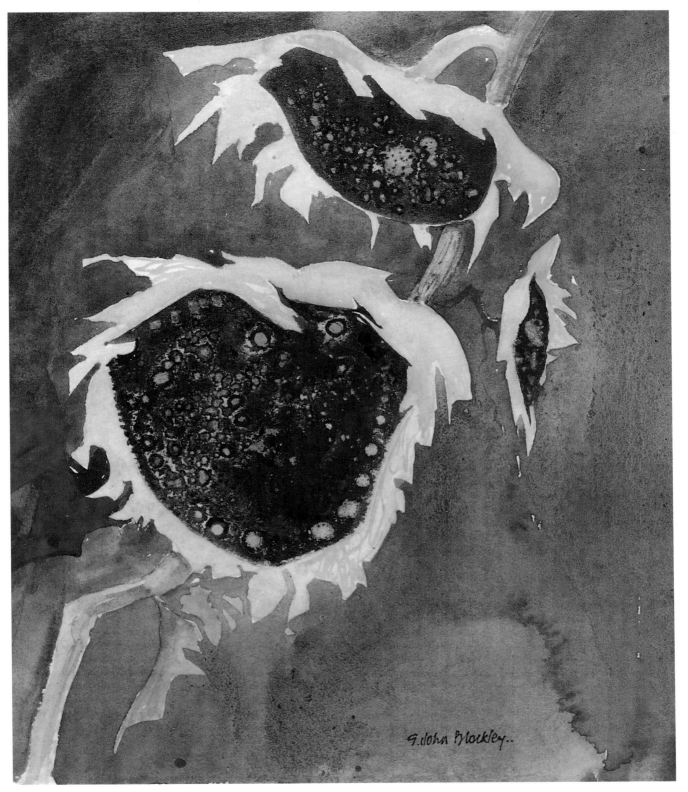

280 x 240 mm (11 x 9½ in)

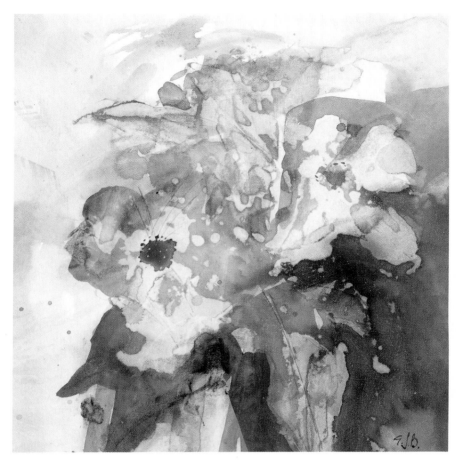

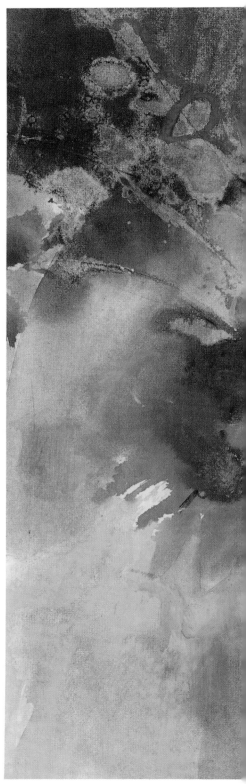

I ENJOY the exuberance of painting flowers with transparent watercolour, seeing them in terms of colour and luminosity rather than botanical accuracy. My temperamental approach to flower painting is one of immediacy; I prefer to stuff a handful of flowers into a jam jar and to work at high speed. The painting above, for instance, is a small, spontaneous impression of flowers, in which I tried to express the translucency of the petals, the light falling on them, and their porcelain smoothness. It is intended to convey the sense of the flowers rather than portray an exact representation of them.

Flower painting is demanding in terms of watercolour dexterity and resourcefulness. It entails controlling washes, letting colours blend, making wet-into-wet smudges and dots, placing hard edges to explain occasional form – a leaf perhaps, or the edge of a petal – sudden high-lights and soft lights, plenty of water, very white paper, and colours emerging and disappearing. I think the excitement of flower painting for me derives perhaps from the opportunity it provides to practise these fundamental processes.

The three paintings of flowers on the following pages were painted with the same colours but on different paper surfaces to give different effects. The background colours are mostly mixtures of Indigo and Payne's Grey, providing a neutral backcloth to emphasize the colours in the flowers. These were painted mainly with Crimson Alizarin, sometimes muted with a little of the grey background mixture but with highlights of pure colour. Occasionally I inclined the red towards purple by adding Phthalo Blue, and some Cadmium Orange was also added in places. The greens are various dilutions of Hooker's Green mixed with Auerolin.

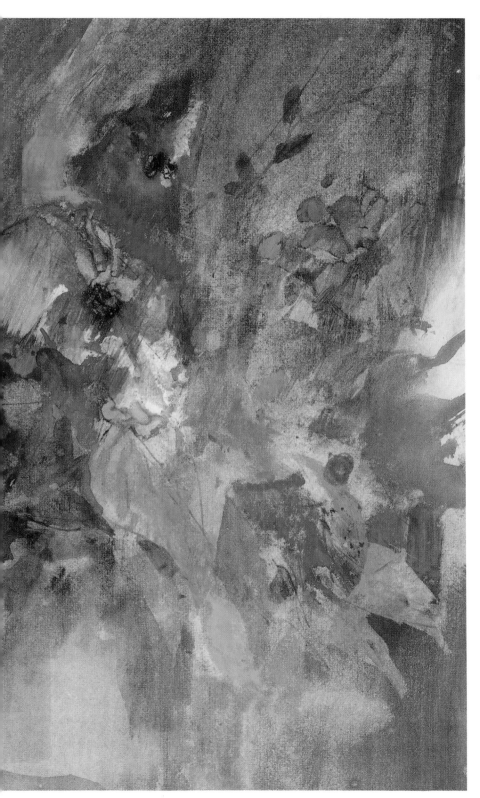

290 x 255 mm (11½ x 10 in)

Vase of Flowers 1

This was painted on Not (cold-pressed) paper, which is discreetly textured and is my favourite surface. I used it for most of the paintings in this book. It accepts colour washes well and yet is sufficiently smooth to draw on. Although not so evident in this painting, I very often incorporate lines drawn with a pen dipped in watercolour when working on this surface.

In this painting I tried to contain the strongest impact of light on the central red bloom and the sharp-edged pointed leaf below it. This flower is streaked with light, the effect obtained by scraping out some of the paint while wet. The flower just above it was painted wet into wet, with a sudden highlight of red. Hints of leaves appear in the background.

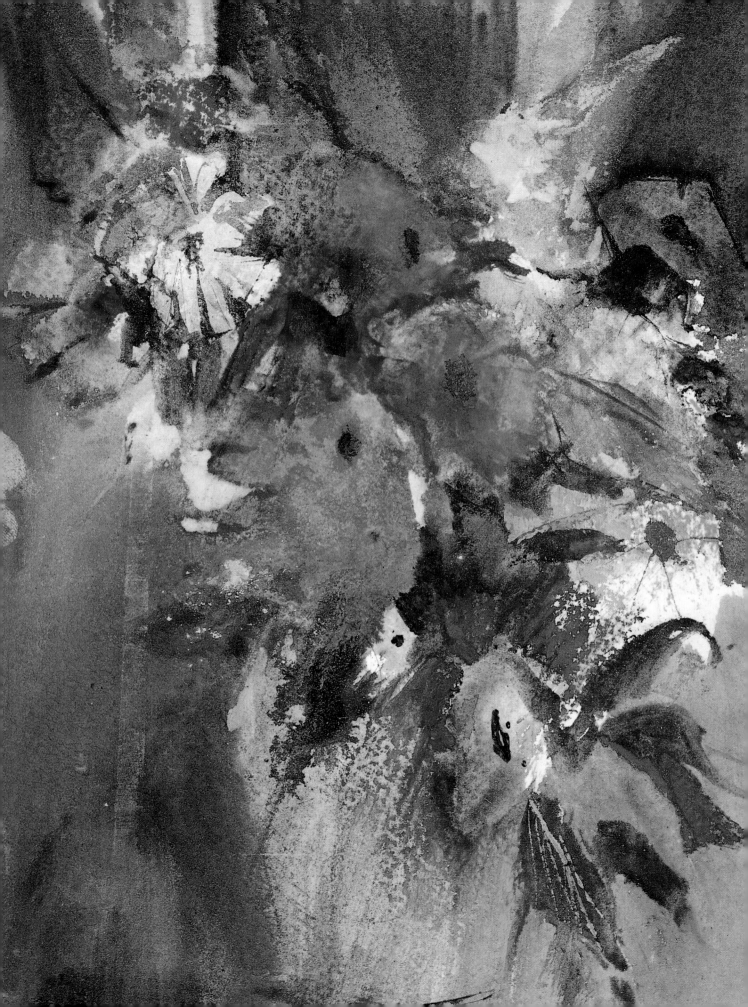

Vase of Flowers 2 (left)

I used Rough paper for this painting. This has a surface which is heavily textured and encourages broad treatment. The texture is useful for obtaining passages of dragged colour, as in the case of the vase here where I dragged dark green colour over a first wash of paler green. Although the paper can be effectively used to express vigour and sparkle, I rarely use it in fact since I prefer the more sensitive Not paper.

I let my hair down with the colour in this painting, placing red against complementary green. It was done vigorously and employed traditional washes of colour applied with a big floppy pointed brush. I scored lines of dragged paint with an old hog brush to give an effect of broken light.

290 x 205 mm (11½ x 8 in)

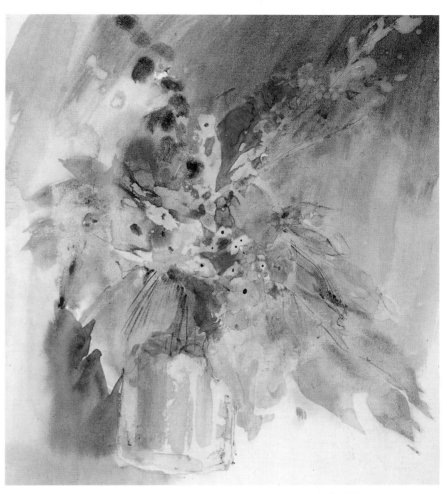

290 x 255 mm (11½ x 10 in)

Vase of Flowers 3

This was done on Hot-pressed paper. This has a very smooth surface on which wash control is not easy; but with experienced handling it allows delightful modulations of colour.

The painting shows a more gentle result, although it was still painted with vigour. The flower shapes are mainly soft and blurred, achieved by painting them into a still-wet first wash of varied colour. The occasional hard-edged shapes help to accentuate the general softness and provide anchor points in the painting to hold the eye momentarily. The soft light parts were blotted out here, although a similar effect can also be obtained by other means. For example, sometimes I dry parts of a painting with a hair dryer, leaving other parts still wet. Soft-edged passages of light can then be produced by carefully washing the wet parts away in a bath.

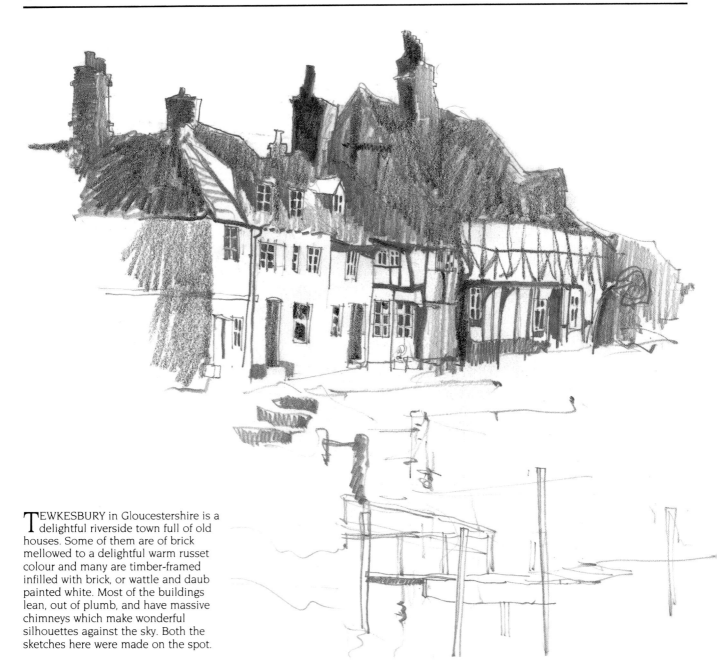

Pencil drawing, 255 x 280 mm (10 x 11 in)

TEWKESBURY in Gloucestershire is a delightful riverside town full of old houses. Some of them are of brick mellowed to a delightful warm russet colour and many are timber-framed infilled with brick, or wattle and daub painted white. Most of the buildings lean, out of plumb, and have massive chimneys which make wonderful silhouettes against the sky. Both the sketches here were made on the spot.

Tewkesbury

In this first sketch the proportion and details of the buildings were fairly accurately observed and recorded. The shapes of the chimneys, the bulk of the roof, the number of window panes, the position of the windows relative to each other are all correctly judged. However, the sketch does feature an element of personal interpretation. I was interested in the roof tops and the chimneys as a single mass and so I blurred individual roofs by strong pencil strokes into one big dark block. I remember the roof details – the uneven tiles, hand-made, and the undulating surface of the roof as the tiles followed the depressions of the centuries-old sagging roof timbers – but in the sketch these are ignored in favour of the scribbled mass of dark aimed at describing the solidity and bulk of roof.

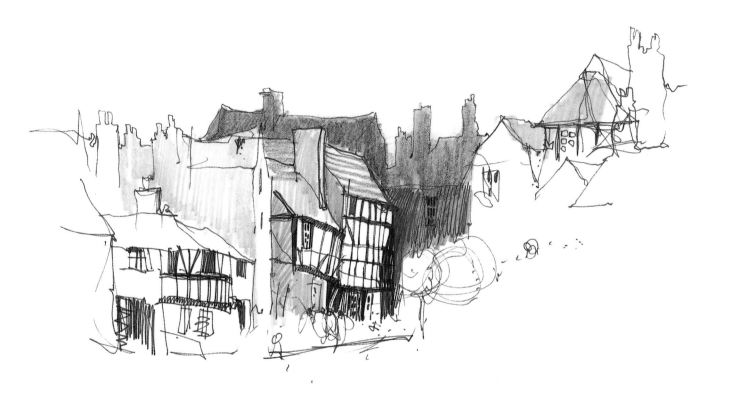

Ink drawing, 125 x 255 mm (5 x 10)

Tewkesbury

The second sketch was done very rapidly with a fine felt-tip pen and a pencil to block in areas of tone. The felt-tip linework is thin and spidery and moves over the smooth-surfaced paper with a feeling of continuity, up and down the chimneys and along the roof top. This is a brief, spontaneous note but it adequately recalls for me the character of the place with its huddled buildings, squat buildings, thin buildings squeezed between others, and the pattern of the timber frames and their white plastered infilling.

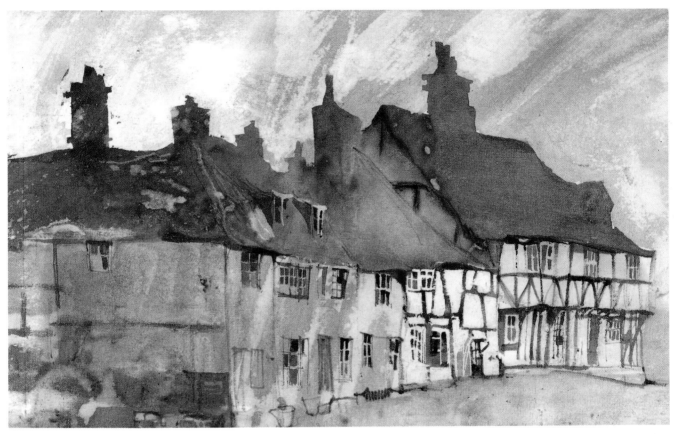

140 x 215 mm (5½ x 8½ in)

PERHAPS the initial interpretation of a subject at the time of making the sketch, or the type of sketch itself, either spontaneous or considered, has influence on the subsequent painting. Certainly the first sketch of Tewkesbury is robust in character, solid and fairly literal, and the first painting copies this treatment with the roofs painted in areas of tone, the window panes all depicted and the timber framework carefully observed. The influence of the sketch is obvious.

The second interpretation has more freedom in its style and is intended as no more than a colour sketch – for fun – but it does show some selectivity and imagination. The chimneys are emphasized and they in turn emphasize the small area of white building, which is sharp and decisive, on a tongue-in-cheek background of orange and palest blue.

Tewkesbury 1

In this painting the sky was masked, leaving white paper for the buildings. Once they had been painted, the masking fluid was removed to reveal the sharp, precise edge to the roof top and chimneys – the same process as was used for St James's Palace 1. Payne's Grey was mostly used for the sky and this colour was continued over parts of the building face. The central chimney was painted with Crimson Alizarin modified with Payne's Grey, whereas Burnt Umber was used for the roof on the left and Burnt Umber mixed with Payne's Grey for the roof on the right.

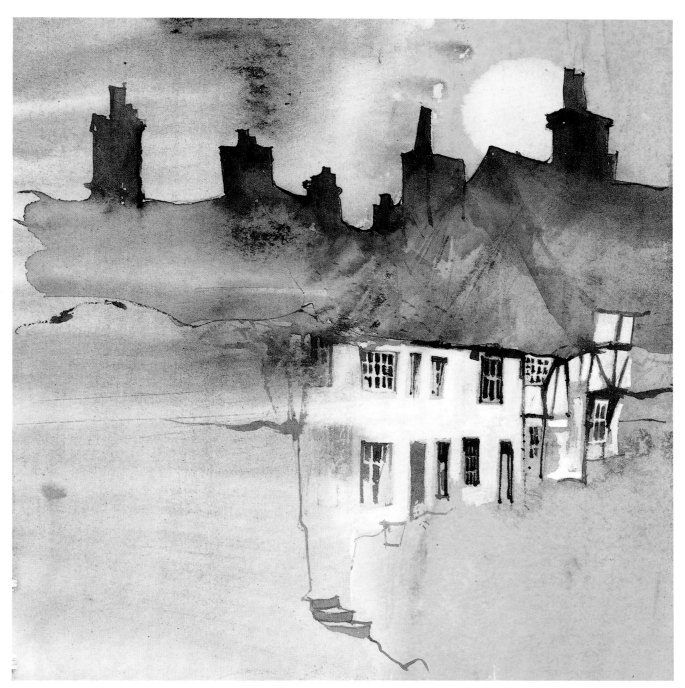

190 x 165 mm (7½ x 6½ in)

Tewkesbury 2

Here a very pale Indigo wash, blending to Cadmium Orange, was washed all over the paper, and then the roof and dark chimneys were added, using Burnt Umber mixed with Payne's Grey. The walls of the cottage were put in last with white gouache. This time the chimneys and roof edges were made sharp and edgy by outlining them with pen and watercolour. This was done while they were still wet so that the line would not be too obvious.

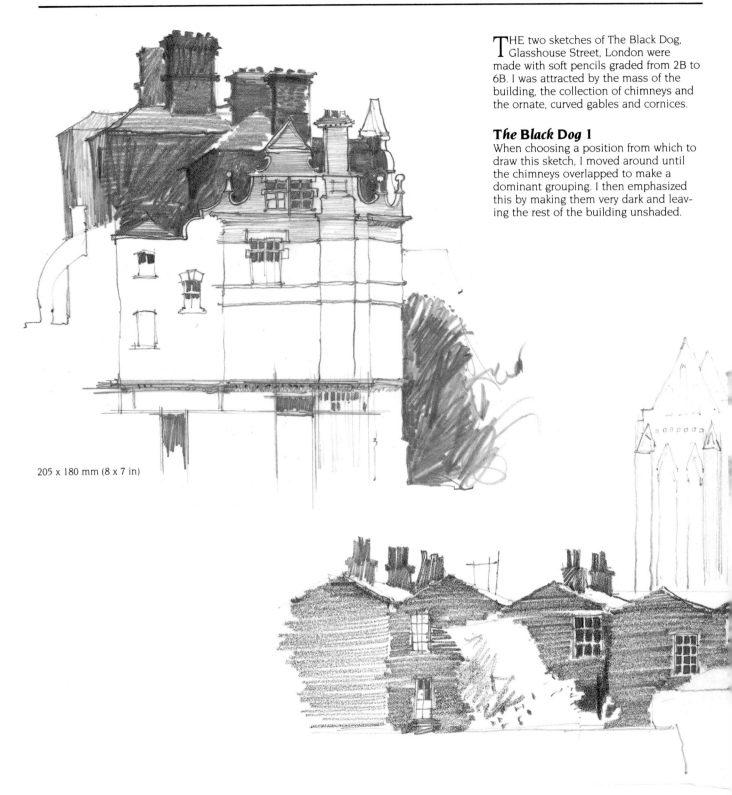

THE two sketches of The Black Dog, Glasshouse Street, London were made with soft pencils graded from 2B to 6B. I was attracted by the mass of the building, the collection of chimneys and the ornate, curved gables and cornices.

The Black Dog 1
When choosing a position from which to draw this sketch, I moved around until the chimneys overlapped to make a dominant grouping. I then emphasized this by making them very dark and leaving the rest of the building unshaded.

205 x 180 mm (8 x 7 in)

205 x 405 mm (8 x 16 in)

The Black Dog 2

Here the viewpoint shows the building as being composed of a number of tall boxes stuck together, with the direction of the lighting producing a counter-change pattern of dark, light, dark. The viewpoint, in fact, is from a spot only slightly to the left of the first sketch and yet the resultant image is very different.

I prefer to choose a viewpoint quickly. It is best when the reaction to a subject is instantaneous and when the compulsion to draw or paint it is immediate. Continually walking around to discover the best view can lead to indecisiveness, so I tend to go for the love or hate at first sight approach. On the other hand, however, it can be interesting to compare one viewpoint with another, seeing how shapes change, how spaces alter, or how separate elements of a view overlap when seen from another angle, perhaps creating different patterns of light and dark.

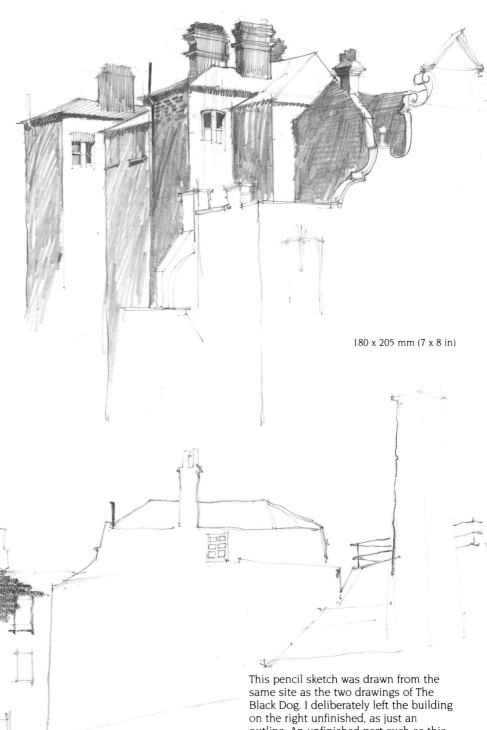

180 x 205 mm (7 x 8 in)

This pencil sketch was drawn from the same site as the two drawings of The Black Dog. I deliberately left the building on the right unfinished, as just an outline. An unfinished part such as this, placed alongside a mass of dark buildings as in this sketch, creates more interest than if the same treatment had been used throughout.

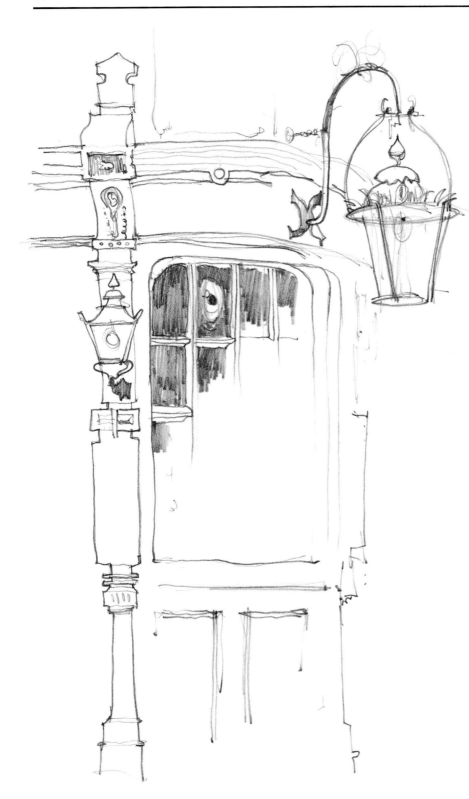

Pencil drawing, 230 x 150 mm (9 x 6 in)

Hand and Racquet 1
I made this drawing of a pub in Orange Street, London, on a day of pouring rain, from the shelter of a doorway across the narrow street. The conditions were decidedly uncomfortable, with cars throwing the puddles of rainwater at my legs, and so I concentrated on the ornamental qualities of the door and windows, registering just enough information to be able to paint from the drawing when back in the studio.

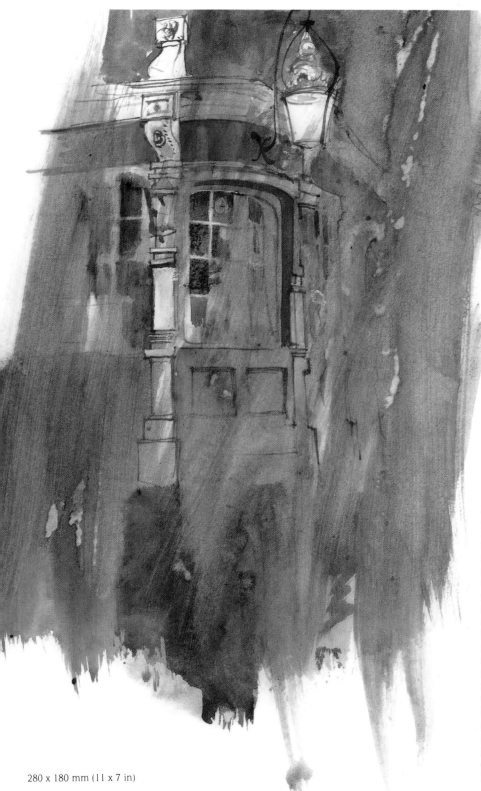

280 x 180 mm (11 x 7 in)

Hand and Racquet 2

In the studio I tried to recapture the spirit of the day on which I'd made the sketch opposite, concentrating only on essential detail emerging through the wetness. The initial drawing was made directly with a fine brush and watercolour, without any preliminary pencil drawing. Then I washed in passages of Sap Green, Indigo and Crimson Alizarin on the dry paper and immediately sliced a housepainter's brush through the paint to create a rain-like effect. I deliberately aimed for an unfinished look in keeping with the urgency of the day, although I highlighted one of the vertical columns and part of the window frame. Opposite and higher up in the picture, the lamp provides a further highlight. This was a deliberate ploy in order to balance the highlights in the painting.

Hand and Racquet 3

I made this drawing on the same day as
the one on page 50. It was still raining,
very uncomfortable, and so again I
concentrated on a few chosen details. I
liked the lamp suspended in space from
its curved ornamental bracket. I also
liked the simple rectangular columns
which flank the door.

 Although the drawing was made
quickly, it shows an instinctive selectivity
in the placing and emphasis of the
various elements. The curved features –
the lamp brackets, the rounded mould-
ings and cornices of the building, and
the curved window top – are all collected
in one part of the drawing, whereas the
rest of the sketch concentrates on the
linear, rectangular features.

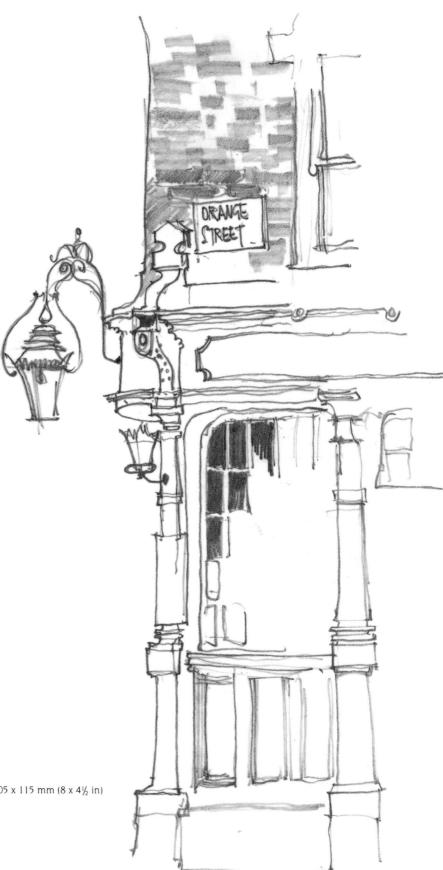

Pencil drawing, 205 x 115 mm (8 x 4½ in)

Hand and Racquet 4

Here I used the same processes as in the painting on page 51, starting with fine brush drawing and progressing to broad washes applied with a housepainter's brush. I decided to subdue my interest in the ornamental lamp and instead concentrated one main passage of light in the column which extends vertically through the painting. This vertical passage of light is supported by the secondary highlights in the window and in the slanting rain.

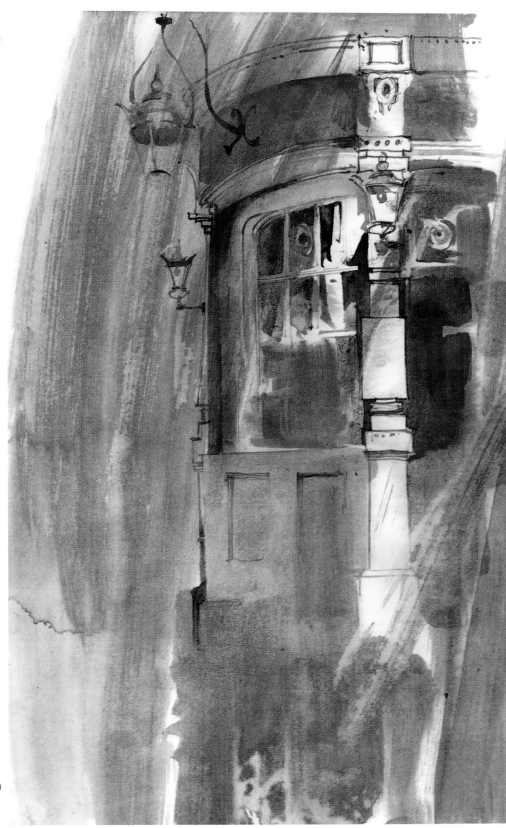

290 x 180 mm (11½ x 7 in)

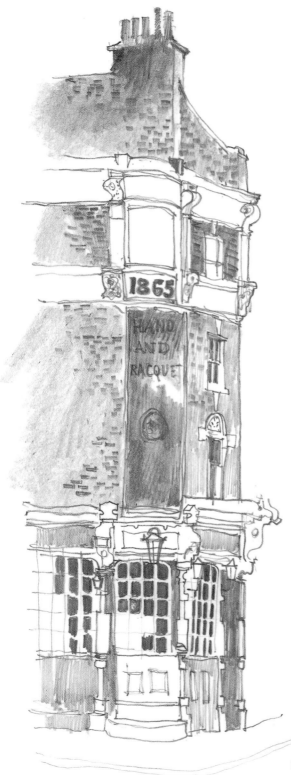

Hand and Racquet 5

I returned to the same place a few weeks later on a dry day so that I was able to walk about and not be restricted to a sheltering doorway. This time I was able to view the building from some distance away and was impressed by its height, so I made the drawing tall and narrow to reflect that. The dry day made a further contribution, for the red strip above the windows (see opposite) looked intensely bright in contrast with the textured, yellow London brick blackened to sombre bronze. I also had time on this occasion to draw the chequered pattern of the dark window panes and put in a great deal more detail overall.

Pencil drawing, 255 x 90 mm (10 x 3½ in)

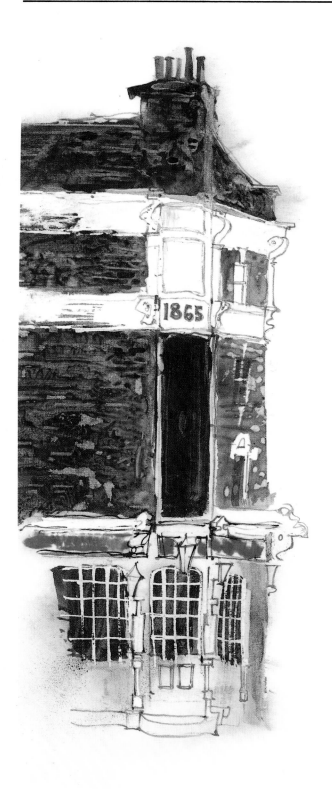

255 x 90 mm (10 x 3½ in)

Hand and Racquet 6

Back in the studio I copied the drawing, working directly with a fine brush and watercolour, and then applied the colour. The white parts of the picture were masked with masking fluid so that the dark tones could be washed in freely. The textured brickwork was obtained by applying Burnt Umber mixed with Payne's Grey thickly, then spattering water into it to create uneven drying. I waited until the paint was nearly dry then hosed the painting under a tap – the very wet parts washed away immediately, leaving a textured effect. Further washing loosened and removed excess pigment from the thick wash, leaving the paper stained to a dark but translucent colour.

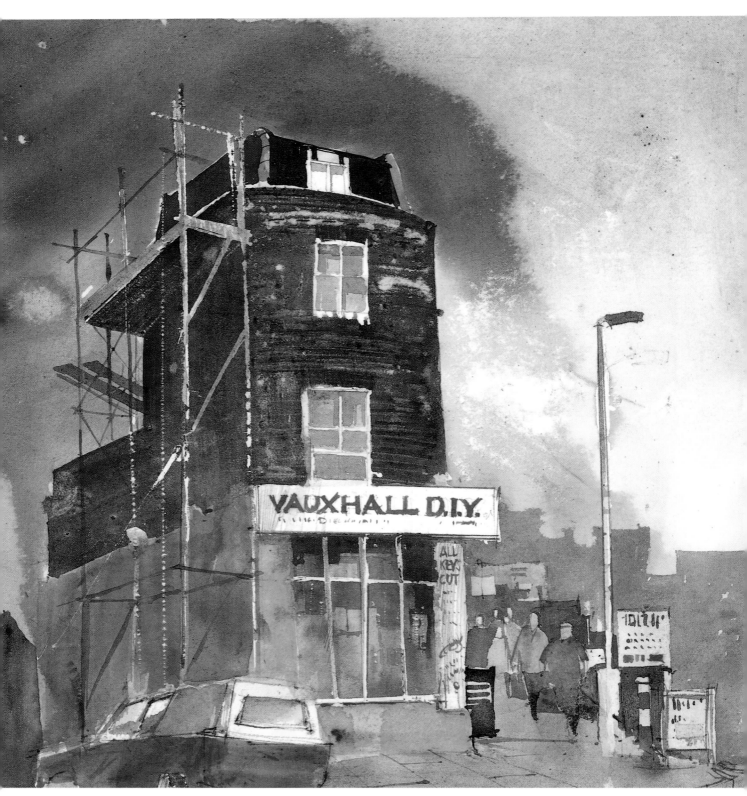

215 x 215 mm (8½ x 8½ in)

'Do It Yourself' Shop, London (*left*)

I was intrigued by this very tall building standing at the corner of the street. It is interesting that the front of the building is slightly curved and I wanted to show this, as well as the height of the building and the busy colour. The scaffolding and the tall lamp post both help to convey the feeling of height.

My painting originally contained quite a large area of foreground, but on masking it experimentally with a piece of paper I decided that the composition was improved by omitting it. The sense of height seemed greater with the building growing almost from the bottom of the paper. Also, reducing the area of the painting seemed to concentrate the impact of the Cadmium Red vehicle, the red lettering and the red-shirted figure, strident against the Cadmium Orange paint and contrasting with the quiet combination of the deep brown building and the dark blue sky. These colour contrasts are typical of street scenes, created by the variety of advertisements and shops selling anything from newspapers, magazines and radio spares to furniture, junk, sandwiches, and Pepsi Cola – as the sketches on the right show. So I cut away a third of the painting to concentrate on this particular aspect.

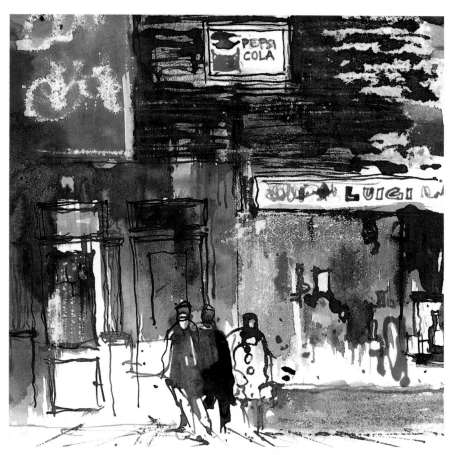

Ink sketch, 135 x 135 mm (5¼ x 5¼ in)

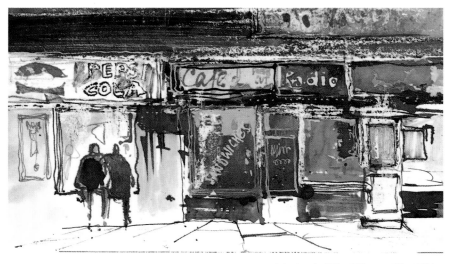

Ink sketch, 110 x 190 mm (4¼ x 7½ in)

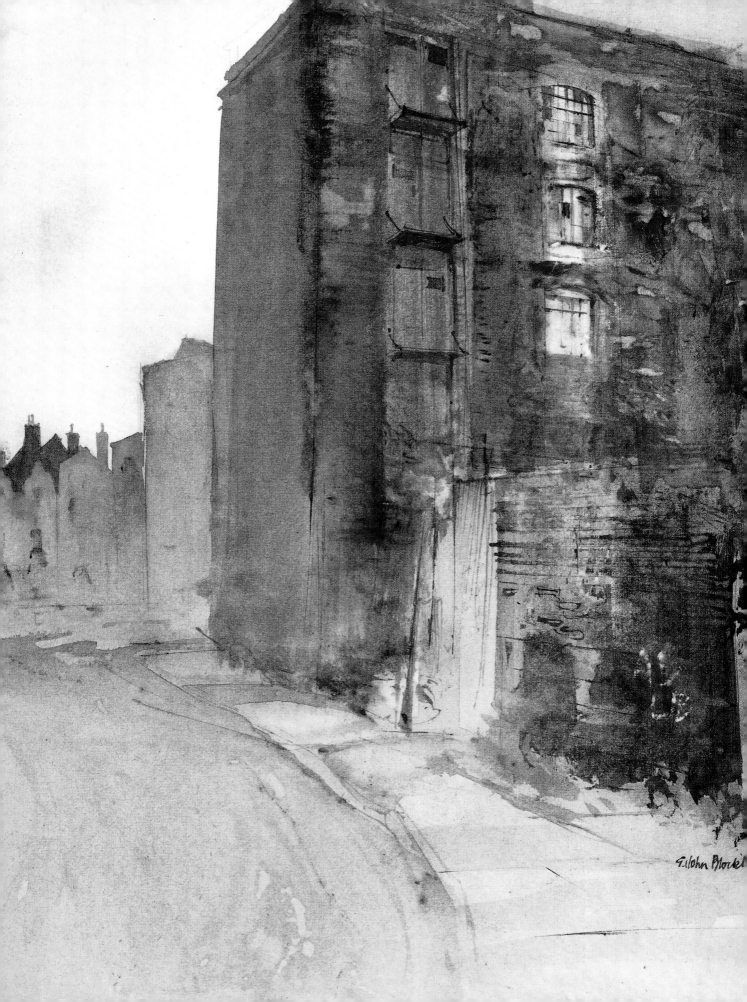

Warehouse, Wapping, London 1

This painting features another tall building – a warehouse close to the River Thames at Wapping in London. The red doors, placed in line one above the other, and the arched windows are typical of these riverside buildings. Their walls are rich with textures and lichen, and their grimy faces are muted to subtle variations of colour. Sadly, many of them are now being demolished and their entrances are often temporarily blocked with corrugated iron.

I used Burnt Umber for the sombre brick and Cadmium Red for the doors, in both cases slightly greying the colours by adding Payne's Grey.

305 x 255 mm (12 x 10 in)

Warehouse, Wapping, London 2

This shows a close-up view of the brick-work of the same warehouse – eroded, bleached, grimy, and with traces of faded grafitti. It illustrates many of the 'mark' techniques described at the beginning of the book, which depend on the constant adjustment of colour, sometimes adding it, sometimes blotting or washing it away. In addition, this painting features another process I often use to achieve particular effects. I deliberately create uneven drying times by drying parts of a wash rapidly with a hair dryer and leaving other parts wet; and sometimes I add water droplets, or simultaneously brush in lines of water with one hand while operating the hair dryer with the other. When I see a satisfactory pattern of wet and dry paint, I immerse the painting in a bath of water, or hose it under a tap to wash away the still-wet parts and leave edges of subtle softness.

240 x 345 mm (9½ x 13½ in)

These details of the warehouse wall
show the textured brickwork, the erosion,
and the industrial stains: London brick,
once yellow but now black; crumbling
brickwork and mortar; grimy bricks
washed by city rain; paint-sprayed bricks,
turned mouldy, white dirtied to grey.

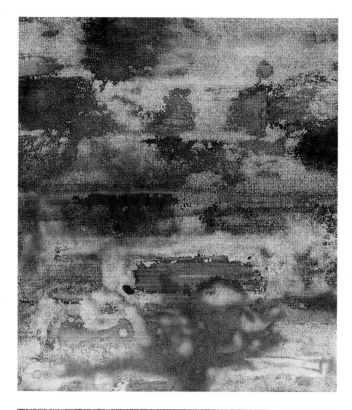

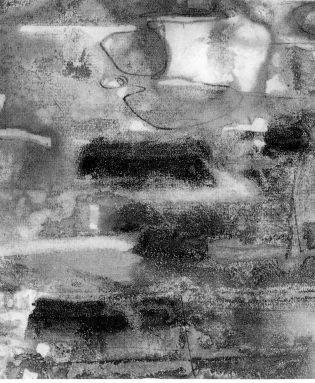

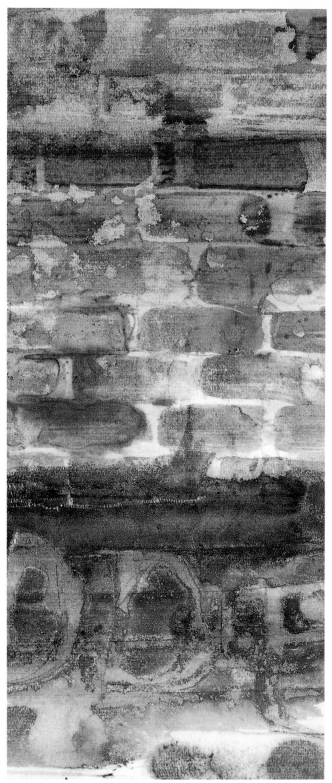

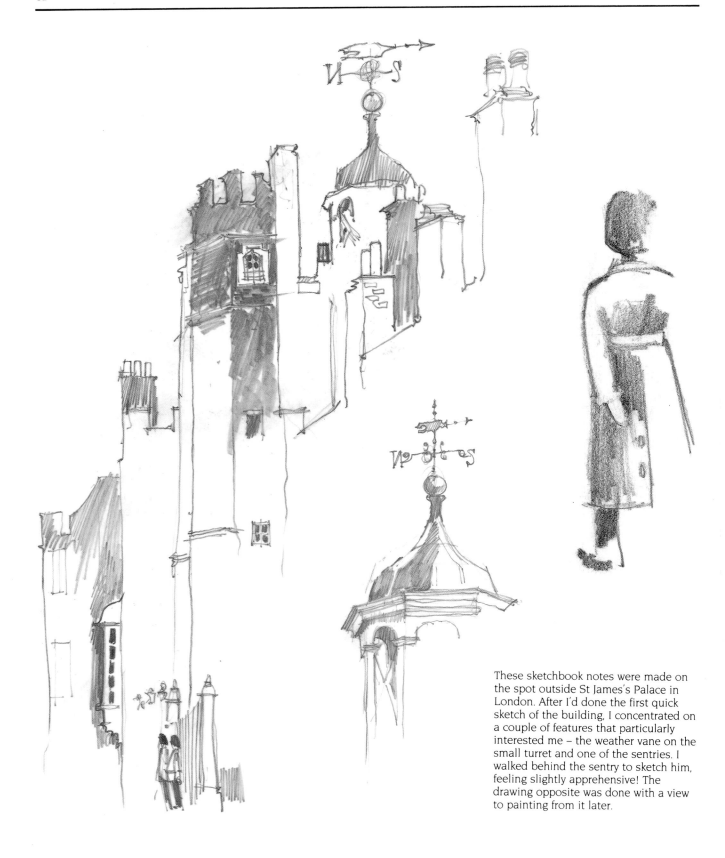

These sketchbook notes were made on the spot outside St James's Palace in London. After I'd done the first quick sketch of the building, I concentrated on a couple of features that particularly interested me – the weather vane on the small turret and one of the sentries. I walked behind the sentry to sketch him, feeling slightly apprehensive! The drawing opposite was done with a view to painting from it later.

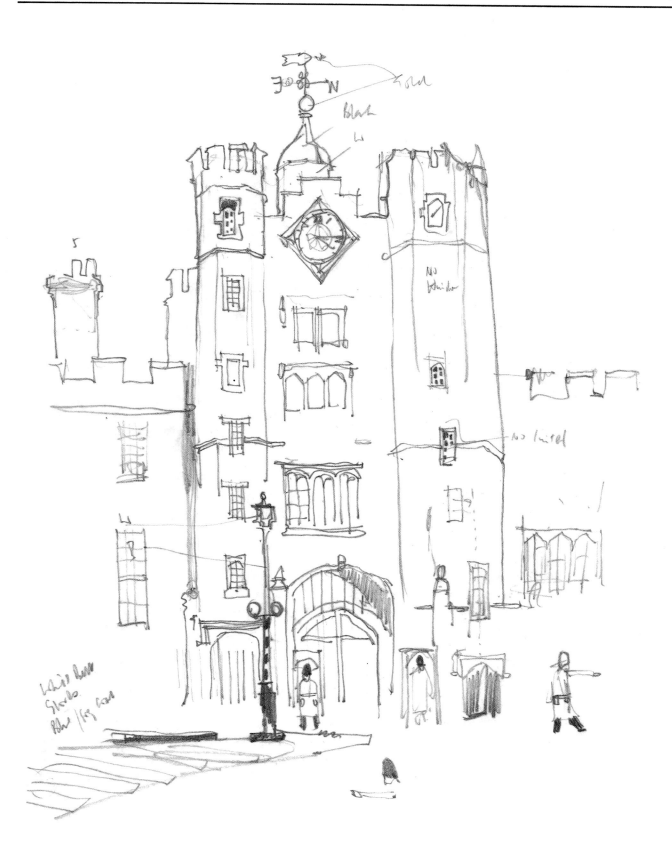

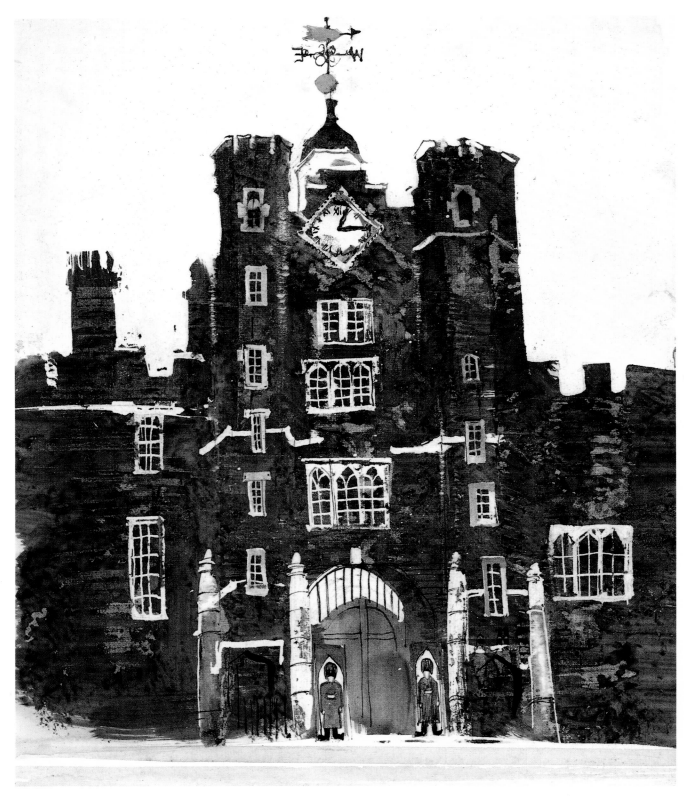

280 x 205 mm (11 x 8 in)

St James's Palace 1

I painted this view of the gatehouse of St James's Palace, London, in the studio working from the drawing on the previous page. I have been attracted by this gateway for many years: the white windows and white bands on the dark chocolate walls, together with the clock, make a strong pattern and impact. I decided to place the dark building against a pale, almost white sky to set it off to maximum effect.

First I masked the sky, windows, clock and other white architectural features with masking fluid. I did this quite freely – carelessly perhaps – because I wanted to produce a fairly sketchy effect rather than precise accuracy. The masking took some time to do but it made it possible for me to apply the subsequent washes quickly without having to paint the building carefully within the confines of a drawn outline. The colour was applied with a worn oil painter's bristle brush, again quickly but using short strokes and dabs of Burnt Umber darkened with Payne's Grey, with bits of Cadmium Orange and Brown Madder Alizarin stippled into this.

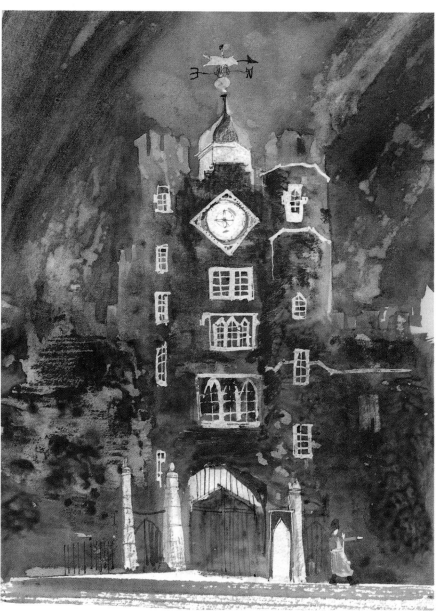

285 x 165 mm (10 x 6½ in)

St James's Palace 2

This is a quick 'throw the paint on' interpretation. I masked the white parts of the building and then dashed the sky in with Indigo, aiming for a dramatic, fairy-castle sky and shaping it around the top of the building. I then splashed water into it, partially dried it with a hair dryer, and washed away the still-wet bits. Next I painted the walls all over with dilute Burnt Umber before scumbling in Burnt Umber and Crimson Alizarin with a bristle brush and a few splashes of water. I dried the painting selectively, leaving some areas to be washed away in order to create a mottled, textured look to the brickwork.

Pencil drawing, 305 x 480 mm (12 x 19 in)

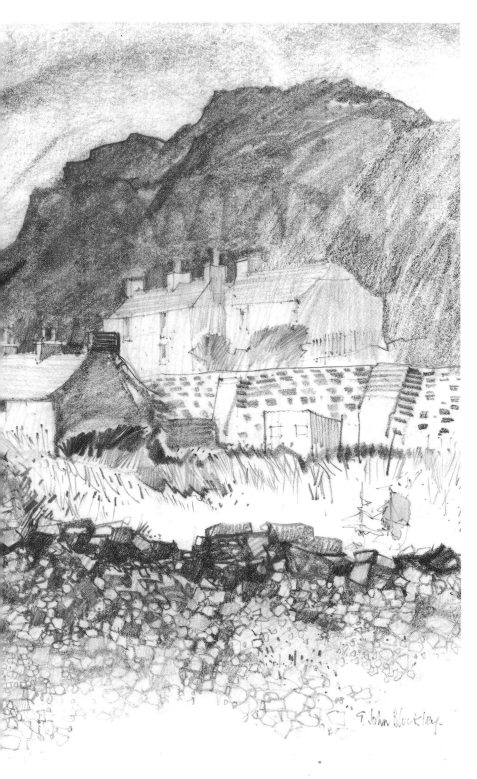

Blaenau-Ffestiniog, North Wales

The background hill in this drawing is a huge tip of debris from the local slate quarry. Everything around it is dark blue slate – the shops, the houses and the surrounding hills. The roof tops are thin slivers of slate; the house walls are built with close-fitting blocks of slate; the pavements are slate; and the field walls are fangs of slate standing upright and tied together with wire.

The day I made the sketch here was wet, cold and melancholy, but I was aware of some special identity and allure of the place. Visually, I was attracted by the dark blue buildings, the castellated chimneys and the foreground debris, seemingly drifting across the face of the quarry workers' cottages huddled in the hollow beyond.

I enjoyed making the drawing, probably spending too long on it, carried away with detailing the fragmented foreground. The paintings on the following pages were made in the comfort of my studio.

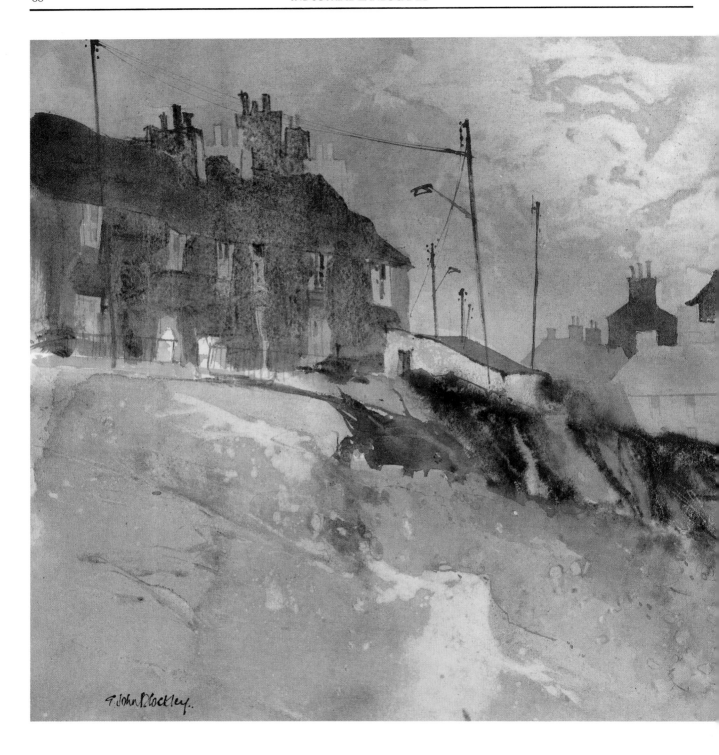

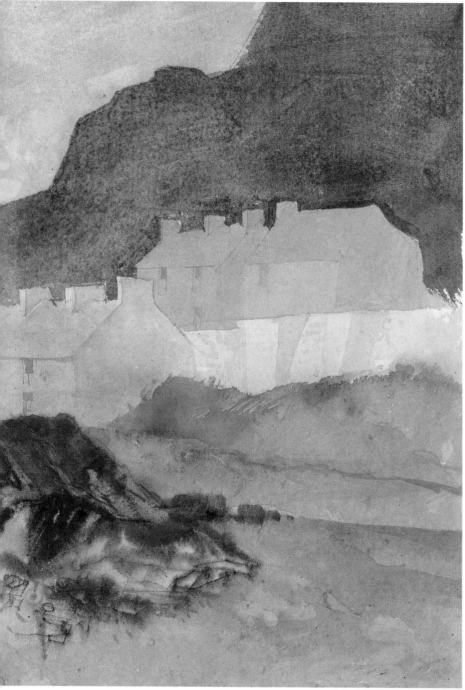

280 x 455 mm (11 x 18 in)

Blaenau-Ffestiniog 1

This is a reasonably faithful copy of the place, blue-grey as I remember it, with nothing happening; waiting perhaps for the rain to clear. I used a wash of Payne's Grey mixed with a little Hooker's Green all over the paper. Then I added the darker features – the house on the left, the background hill, and the dark part of the foreground – using the original mixture with additions of Black, Burnt Umber and Indigo.

The houses on the right were kept light to provide a counterchange of tone: dark foreground against light cottages, dark hill against lighter sky. This sequence of dark, light, dark, light is a frequently used pattern-making device. In this painting, however, my main purpose was to show these houses softly lit and almost insubstantial against the surrounding harshness, and in contrast to the black solidity of the other buildings.

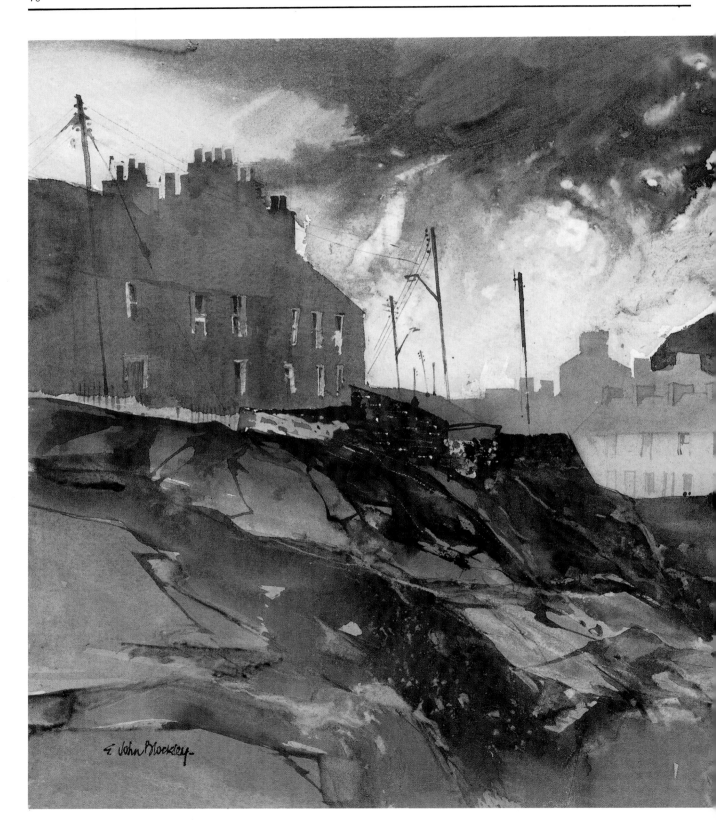

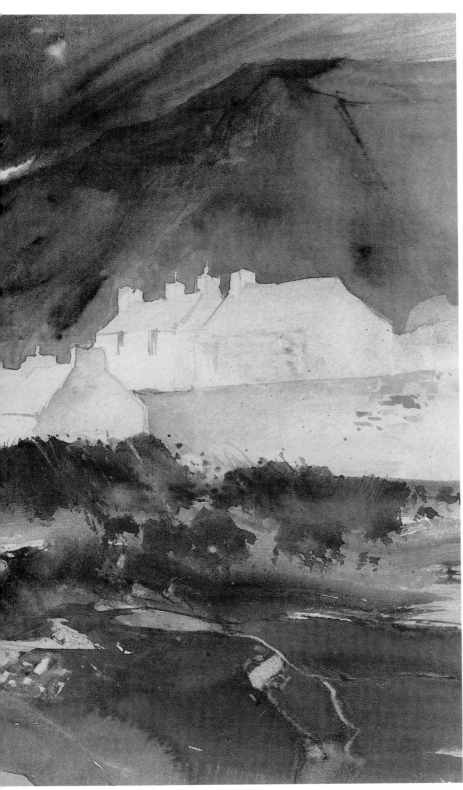

305 x 480 mm (12 x 19 in)

Blaenau-Ffestiniog 2

Here I livened up the scene with a dramatic, almost violent sky. Such skies do occur, with intense lighting appearing at the horizon. This light patch helps to emphasize the telegraph poles and was painted with very dilute Naples Yellow. I used Cadmium Red, very dilute and greyed with a very small amount of Payne's Grey, for the lighter-coloured houses. The other colours are essentially the same as for the painting on the previous page.

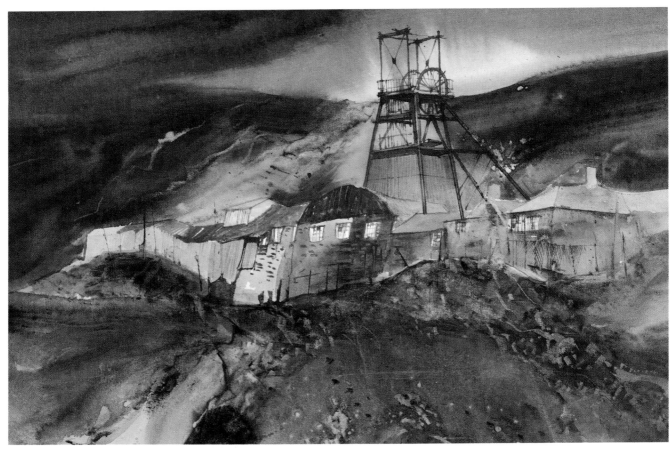

255 x 330 mm (10 x 13 in)

Big Pit 1

Big Pit in Blaenavon, South Wales, is a dramatic structure with its ancillary buildings clustered around it. To the left, these are made of galvanized corrugated iron, some of it new and shiny and some of it old and rusty. These long, low buildings caterpillar over the undulating ground.

The pit was closed down a few years ago and is now being tidied up and turned into a museum displaying its past life. It must have been a vast site in its working days and there is still evidence of working equipment – conveyors, railway lines, foundations of old buildings, bits of machinery – relics adding to the melancholy of the place. Once the pit would have given employment to lots of men but on the day I painted it I saw only one ex-miner walking his whippet dog. I first saw him silhouetted against the sky as he walked along the top of the huge spoil heap behind the pit, then he

came across the flattened ground towards me, circling me two or three times before stopping to talk, from a polite distance away. This seemed to accentuate the emptiness and nostalgia of the place, and yet despite this the grass is growing back. There was even more grass than I have shown in my painting, and it was greener, but my choice of darker colour serves to integrate sky and ground and attempts to convey the mood of the place. The restricted passage of green in the centre also helps to direct the eye towards the pit and provides a useful area of light behind the silhouetted pithead structure.

It was a cold morning and I painted quickly, starting with a very pale wash of Raw Sienna for the light in the sky. Then I added Indigo and Payne's Grey for the rest of the sky, shaping it around the building and continuing it into the fore-

ground, blending in the green, which was mixed from Lemon Yellow modified with a little of the blue-grey sky wash. At this stage the paper was covered with washes of varied, blended colour representing the sky and the foreground. The buildings were an isolated white shape enclosed by these washes. I let the paper dry, but then rewet it on the left and painted in the background hill. This blended softly into the wet paper but remained sharp-edged where the paper was dry, on the right. I also lifted the hill wash away in the centre of the painting, using a moist brush, to regain a light passage in the initial Raw Sienna sky. When this was dry, I painted the pit structure against it. Finally, I filled in the white building shape with washes of dilute Indigo for the corrugated iron walls and Burnt Umber and Brown Madder Alizarin for the brick and rusty iron parts.

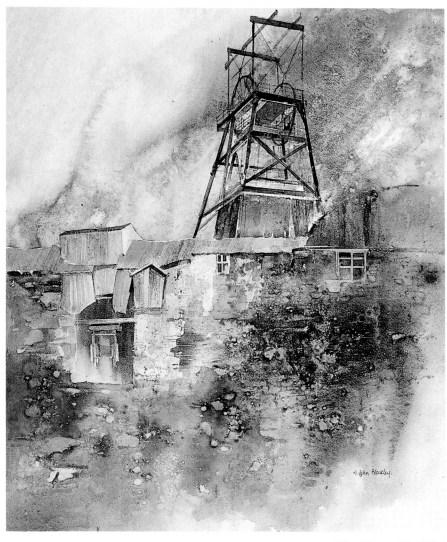

535 x 430 mm (21 x 17 in)

Big Pit 2

In this painting I viewed the pit much nearer, looking up at the pithead winding gear, and from where the textures of the buildings could be clearly seen. The pink brickwork was much darker than I have painted it, but I wanted to highlight it with Cadmium Red against the darkly stained, dank surface alongside. I broke up this dark area into numerous small granulations of light and dark, making an interesting contrast with the relative newness of the pink wall where the patterns of light are bigger and only slightly mottled. Occasional drawing here indicates joints in the brickwork and explains the construction. The architec-

tural details in this area of light – in the roof, in the hanging sheets of corrugated iron, and in the remnants of machinery inside the building – are sharp and crisp. The rounded roof of the building on the right provides variety in the geometry of the building structures. I subdued it by painting in low tones, using the wet-into-wet technique so that it blends sympathetically into the dark wall below. For all these dark surfaces I used Payne's Grey, Indigo and Burnt Umber mixed together in various proportions.

I used a piece of celluloid to paint the pithead structure. The edge of the celluloid was coated with paint, which was

transferred to the painting by pressing the edge of the celluloid onto it, then moving it quickly sideways. By this method a hard-edged, definite band of colour can be obtained. If a softer band is required, a piece of cardboard is ideal – the cardboard absorbs some of the paint applied to its edge so that a less dense line is transferred to the painting.

For the sky I used very pale Raw Sienna, brushing Payne's Grey diagonally into this while it was still wet. The mottled effect was achieved by washing out colour in parts, or by blotting it to produce soft lights in keeping with the textures in the buildings.

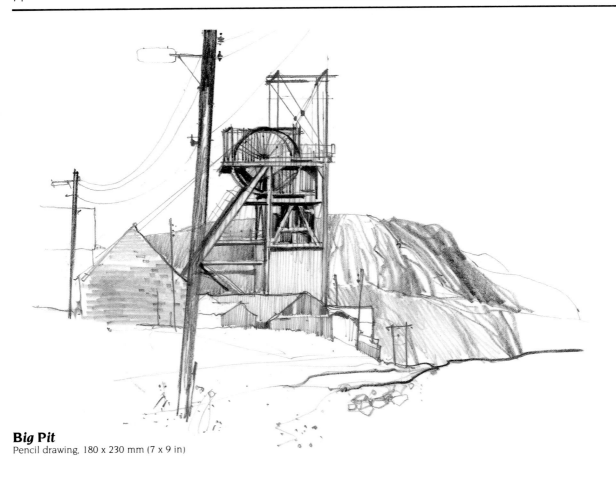

B*ig* **Pit**
Pencil drawing, 180 x 230 mm (7 x 9 in)

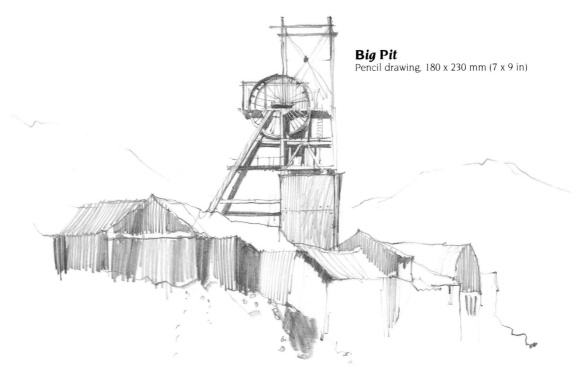

B*ig* **Pit**
Pencil drawing, 180 x 230 mm (7 x 9 in)

180 x 140 mm (7 x 5½ in)

Big Pit 3

This is a fanciful interpretation of the pit, painted from drawings made on the site and illustrated opposite. I pictured the pithead structure black and silhouetted against an angry, orange-red sky. Using Cadmium Red with hints of Cadmium Orange, I painted the sky with circular motions of the brush, revolving around the pithead wheel. Then I made further circular brush strokes using just water so that the orange wash dried unevenly, and

in addition I splashed droplets of water into it. When the sky had partially dried I washed away the still-wet parts to obtain the roughly circular patterns you can see around the wheel. ·

The foreground was painted with Payne's Grey, mixed with a little Phthalo Blue. While this was still damp I flicked fairly thick globules of the same mixture into the wash with a small painting knife, adding at the same time droplets of

water to the paint. When the ground wash was dry I washed away the still-wet globules and droplets of paint and water to create random patches of light in the foreground. The pithead was added after the sky and foreground had dried. For this I used a flat, narrow oil painter's brush and drew the thickness of the structure with one brush movement. The wire fence was drawn with an ordinary dip pen and watercolour.

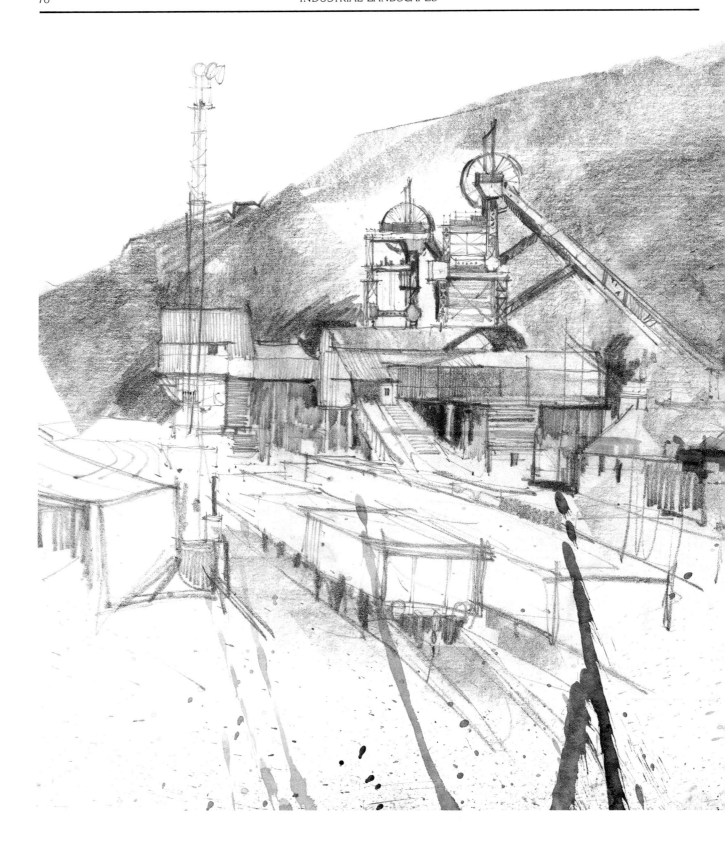

Marine Colliery, Ebbw Vale, South Wales

A main arterial road crosses South Wales, east to west. It is known as the 'Head of the Valleys Road' and climbs high above the surrounding countryside, and from it the vast panorama of industrial South Wales can be seen. The valleys run southwards from this road, in parallel lines, each in a steep-sided cleft. From the road, tiers of houses pile above each other, built in almost continuous rows along the sides of the valleys. These terraced rows are bisected by narrow roads climbing and twisting upwards.

Some houses have blue-grey roofs and walls, others are brick red, each building an echo of its neighbour. Some are individually coloured – splashes of incredible colour enlivening the drabness. The town of Abertillery, in particular, which is not far from the colliery, has unbelievable colour – houses painted chocolate alongside green, their windows orange or purple, with doors opening straight onto the street, or sometimes with a narrow strip of garden and a low wall and iron gates. I turned one corner of a twisting road to see a row of houses which all had their own gates, and every gate post was crowned with a round ball, each one a different colour.

The landscape around here is threaded with valley roads, and packed with buildings, houses, industry and coal mines. Such is the setting for Marine Colliery, tucked into the valley bottom. I sat on a roadside wall to make this drawing of it. It was an exciting sight with the big twin wheels at the top of the lattice-girdered steel structures. The drawing is crude and rough and was done vigorously, dictated by the place – a neat, tidy drawing seemed out of place here. And afterwards, too, I treated it carelessly, placing it on the studio floor where I could see it to paint from. I regard it as a working drawing, now paint-splashed, intended only as a means of recording private information from which to build up a finished painting.

Pencil drawing, 355 x 510 mm (14 x 20 in)

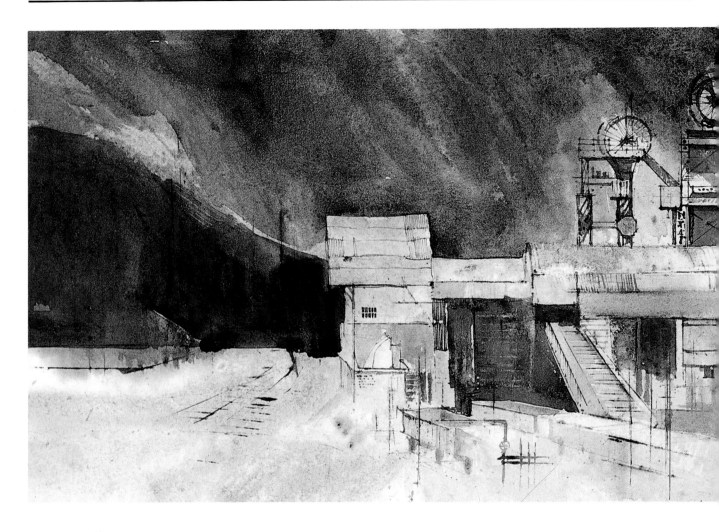

Marine Colliery 1

I painted this in the studio from the drawing on the previous page. I decided to disregard my memory of grimy buildings and paint them bathed in light set against a dark sky. Lighting conditions such as these, with dark, inky blue skies punctured by shafts of weak sunlight, can be very dramatic.

The painting proceeded in two very definite stages. First, I brushed pale washes of colour – very dilute, only just staining the white paper – over the whole area of the painting. Much of

these washes remains uncovered in the finished painting and can be seen in the lightest parts of the building and foreground. Because they were so dilute the white of the paper reflects back through them. I used Raw Sienna and Phthalo Blue, both very diluted, allowing them to touch in places to give a greenish tinge. In parts of the building I strengthened this green mixture and in others I brushed in strokes of Cadmium Red. For the sky towards the right of the painting I used Cadmium Red modified

with Phthalo Blue. By now the paper was covered with a film of transparent, varied colour.

Before commencing the next stage I left the painting until it was bone dry. Then I redampened most of the sky with clean water, keeping just the area of the roofline dry. Next I painted the sky with Phthalo Blue mixed with Payne's Grey, and in places Lamp Black. Around the roof profile, on the dry paper, the edges are sharp but they are softer where they meet the dampened paper. I waited till

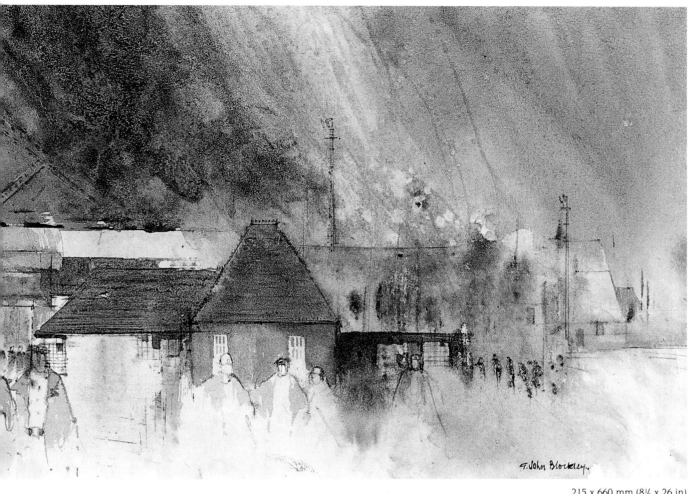

215 x 660 mm (8½ x 26 in)

the paper was dry and then painted the very strong dark blue on the left of the sky, swooping down towards the buildings. I left a strip of light along its upper edge, however. From the drawing on which this painting is based you will see that this steep slope did not actually exist – but I wanted it and enjoyed making the decisive brush stroke curving downwards to achieve it. I feel this dark shape provides effective sharp-edged contrast with the light foreground and the building.

At this stage the painting consisted of a finished sky and light, varied, coloured washes on the building and ground. I developed the buildings next, sometimes with dark, hard-edged shapes, sometimes by dampening the paper locally and brushing in dark, soft-edged shapes. The building on the extreme right of the painting is just a soft smudge, but in other places definition was added by applying lines of watercolour with the sharp edge of an oil painter's knife. Sliced across the paper,

the knife edge, dipped in watercolour, gives a precise, taut line.

Because in the context of the painting I wanted the figures in the foreground to merge into the overall lighting, I only suggested them, using pale colour washes and a little drawing. In reality, however, I remember the miners coming off shift with blackened faces and clothes. Finally, I added the tall steel structures with the wheels that wind the cages of miners to and from the underground workings.

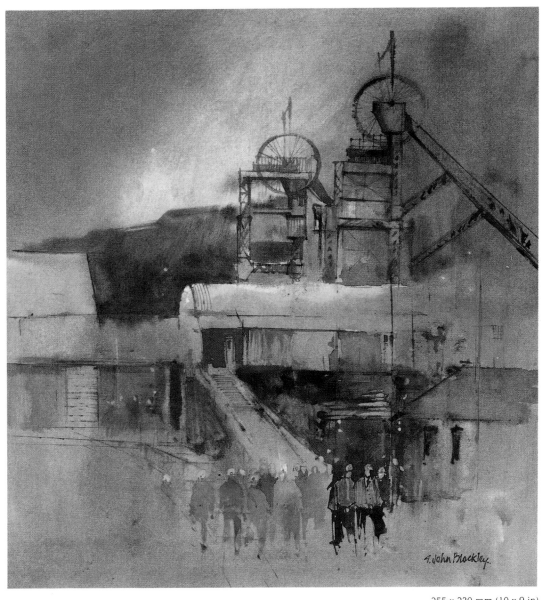

255 x 230 mm (10 x 9 in)

Marine Colliery 2

In this painting I came in for a closer look. The main interest here is concentrated on the colourful roof, brightly lit and backed up by the secondary light in the sky. In fact, the actual roof was not this eye-catching colour – I have some recollection of it being dark green – but I wanted it to be the main source of impact in the painting, almost glowing with light in the darker tones of the colliery atmosphere. The roof on the left has the same colouring, dilute Cadmium

Red, and is also light, although slightly subdued relative to the main roof. The hardest edges are also localized to this part of the painting, especially at the rounded end of the roof, and this helps to draw attention to this area.

Elsewhere, edges are softened and colours muted, mainly Indigo and Crimson Alizarin diluted with Burnt Umber. I have tried just to hint at shapes and things happening within these out-of-focus areas: dots of light and mere

suggestions of figures. In the immediate foreground I quickly indicated groups of miners wearing safety hats and picked out some of them in bright orange overalls, which attracted my eye on the site and which provide useful echoes of the roof colour in the painting. Although the big wheels and their supporting structures were impressive and dominating on the actual site, I understated them on dampened paper so that they do not detract from the main interest – the roof.

Marine Colliery 3

This is just a little doodle with brush and colour, picking out a small area of the scene illustrated opposite. It shows a bit of roof, hints of buildings and figures, and wisps of steam drifting upwards. It was painted mainly wet into wet to give soft, mysterious forms, but was sharpened up with bits of fine, crisp drawing. Within the overall soft treatment I contrived a passage of light tone in the foreground, which continues upwards and leads to the dark opening in the building. This opening is flanked by two light rectangular areas, and by collecting all these light areas together in one continuous passage, the painting is given unity and cohesion. Similarly, the two principal dark areas of blue-black are placed closely together. Light and dark passages scattered indiscriminately around the painting would have created a busy and irritating effect.

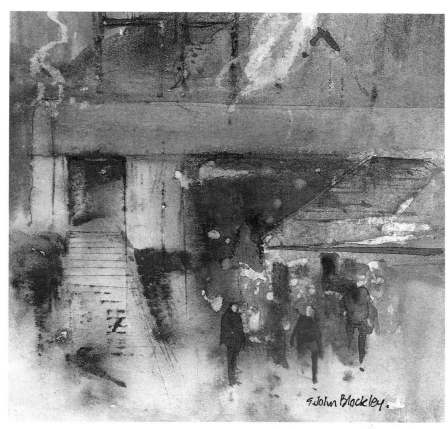

125 x 125 mm (5 x 5 in)

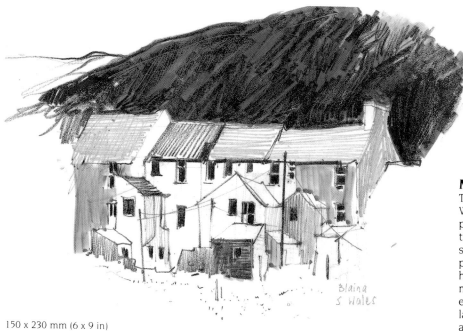

150 x 230 mm (6 x 9 in)

Miners' Cottages

This sketch of cottages in Blaina, South Wales, was made with a thick, black wax pencil. I sharpened it to a point to draw the thin lines of the buildings, but the soft wax quickly rubbed away so that the point became blunted. This enabled me, however, to block in the dark background mass, using a sideways movement. The effectiveness of the drawing relies on this large dark area, the small dark windows, and the whiteness of the buildings.

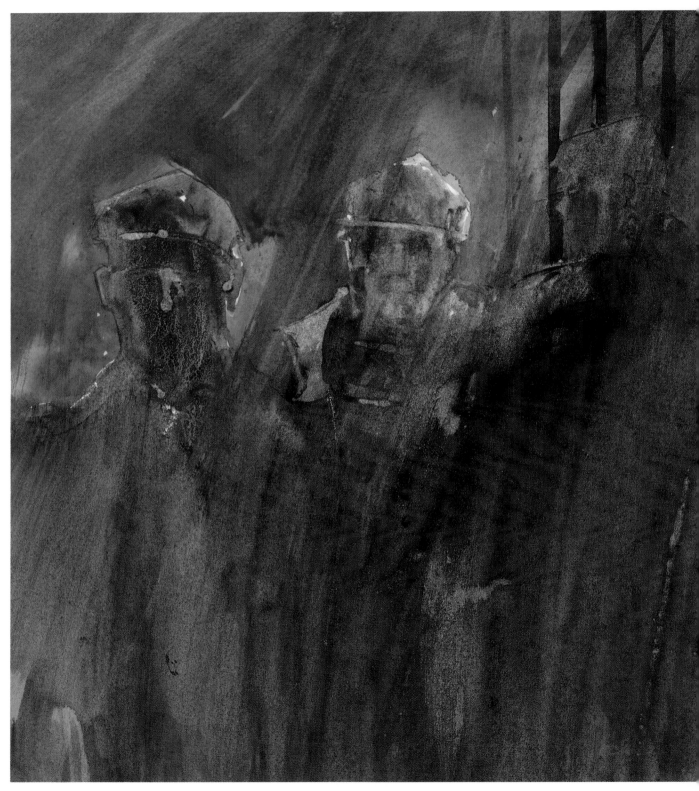

280 x 230 mm (11 x 9 in)

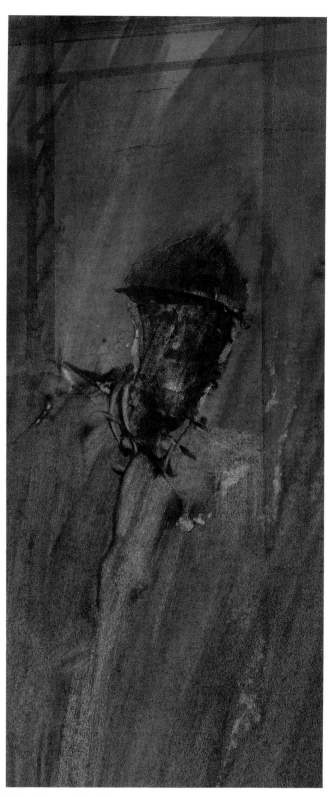

255 x 100 mm (10 x 4 in)

Miners

Both these paintings were done in the studio and record my meeting the men as they came off shift at the end of their working day. I painted aggressively, using worn brushes, sweeping the colour onto the paper and trying to convey grimy figures, black with coal dust, in an angry environment suggested by the red background.

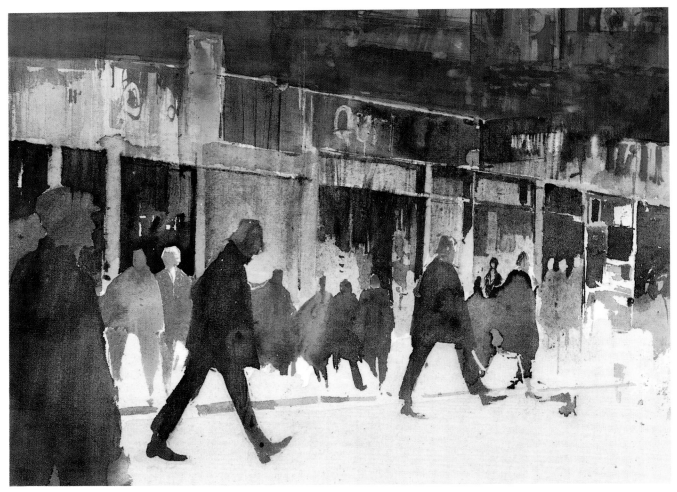

THE following three paintings of shoppers were made from memory with the aid of a few minimal sketch notes made previously on the spot. My overall impression of the scene was of people poised on the pavement edge, individual figures hurrying across the road, shop fronts with large sheets of shining glass, and glints of light and colour. I have made three different interpretations – one a daytime scene, one in the evening and another in the evening with rain. In them the figures appear as individuals, as isolated groups, or as groups of people merging together, depending on the lighting and weather.

Shoppers 1

In this painting I concentrated the action in two figures and painted them as simple silhouetted shapes, almost stylized and with an exaggerated striding movement. They are placed against a background of stationary groups of figures, painted not as individual persons, but as one continuous wash of changing colour. The red coat of one blends into the yellow coat of another, so that the bodies become one mass, with small blots of colour for their heads. They are symbols, representing a group of figures in general rather than accurately observed individuals. These were very easy to paint: one big patch of

varying colour, then dot, dot, dot, with the point of the brush to make the heads. The legs were indicated with flicks of the brush made quickly but with considered direction so that they seem to echo the legs of the larger, striding figures and thereby identify with them. They look as though in a moment or so they too will be hurrying across the road.

The shop fronts are unified by the use of a pale green colour, and the areas of red along the top of the windows link up with the red in some of the figures. I deliberately left the road as a flat wash of light colour to give relief to the darker tones above and to provide a restful area.

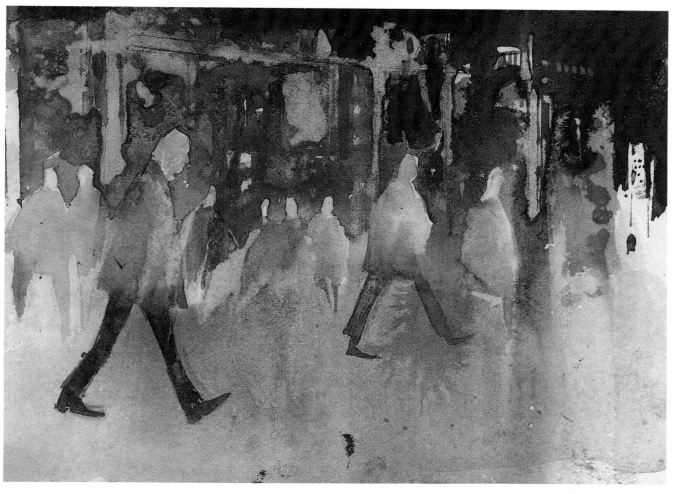

125 x 180 mm (5 x 7 in)

Shoppers 2

This is an imagined evening scene based on the previous painting. I let the background colours flood wet into wet downwards across the road to suggest reflected lights. Because of the evening lighting conditions, the structural elements of the buildings are suppressed and the figures are less sharply portrayed, definition being confined mainly to their heads and feet. The heads are shown as light shapes strung across the paper and are echoed by other small light shapes in the background. All these light spots are contained in the top half of the painting; the bottom half is one wash of softly blending colours.

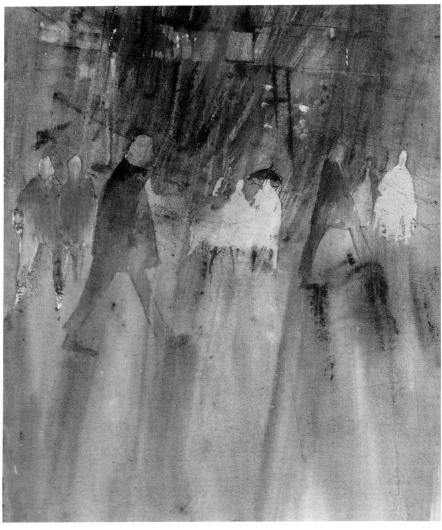

180 x 150 mm (7 x 6 in)

Shoppers 3

This shows another imagined scene, this time with rain. I have chosen to reduce the number of figures and to highlight one small central group. This was painted as a hard-edged crisp shape and in bright, sharp yellow. A single figure at the extreme right of the painting provides an echoing shape – it is also sharp-edged and tending to yellow, but is less bright than the group in the middle so that it becomes a secondary form.

I began by masking the groups of figures with masking fluid and then I brushed blue-grey colour all over the paper. Into the top half of this I brushed traces of red, green and orange. These colour washes were made with a flat housepainter's brush, working down-wards over the paper with slanting brush strokes. When they were dry, I developed the background shop details to a fairly recognizable degree, then I made vigor-ous, slanting strokes with the house-painter's brush through the wet paint to suggest the driving rain. At the same time, however, I tried to leave some suggestions of the building details undisturbed. Finally, I removed the masking fluid and tinted in the colourful figures.

Woman with Shopping Basket

Here I tried to contrast the sensitive, slight drawing of the woman and her basket with the coarse, eroded texture of the building. I began by applying a pale wash of Raw Sienna, slightly tinted with Cadmium Red, all over the paper; this can be seen in the light patches of the rough wall and especially in the bottom left corner of the painting. When this was dry I washed darker colours – Burnt Umber, Payne's Grey, Cadmium Red and Phthalo Green – over the upper half, splashing water into it when half dry, then drying it in places with a hair dryer and washing out other parts to create the blotched effect of eroded stonework. Then I put in the suggestion of a window by coating the edge of a piece of cardboard with paint and pressing it onto the damp paper. The lettering over the window was painted carefully with a small brush, but then immediately partly destroyed to convey decay and wear. It is fun to paint a descriptive part like this with care, then break it down with a rough-bristled brush, dragging some of the paint across the neighbouring areas, to create a shabby effect.

To draw the figure, I had to change my way of working completely – from headlong speed to nervous caution. Using an ordinary dip pen and watercolour I put in the figure with sensitive, very slight line. To achieve this I wet the paper so that a film of water lay on the surface and then I gently lowered the tip of the pen onto the shiny wet pool: it was fascinating to watch the line form on the surface of the water and see it gradually sink into the paper as the water was absorbed. This technique has the effect of forming a line which is only just apparent and which melts softly into the paper. For the woman's face and the basket I brushed in blushes of soft colour, then firmed up the details with pen lines and dots of colour.

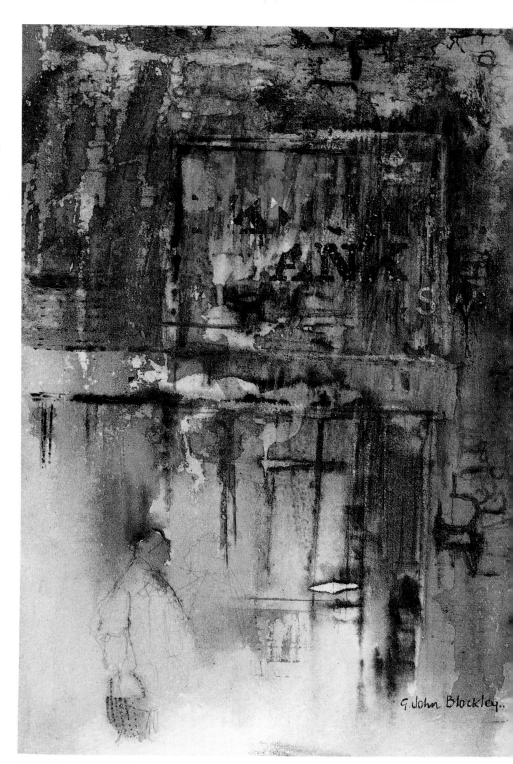

240 x 165 mm (9½ x 6½ in)

EVERY year gypsies come to the village where I live with their colourful caravans and stay for a week or two. They tether their horses on the grass alongside the road, and sit themselves around a fire most of the day and into the evening – even in the rain. Occasionally the women come to the houses, in pairs, carrying large baskets with things to sell.

The four paintings here and overleaf are hurried interpretations made from memory after a number of quick, searching looks.

Gypsy 1

I have a strong memory of this gypsy profile and the black hair, dark features and woollen shawl over a patterned dress. I painted the figure in strong sombre darks, using similar strength of tone in the face and in the dress, although the pattern on this provides some relief. The hair is black, and for the face I mixed Raw Sienna with a little Black. I used blue for the dress with the

whirls of black pattern made by twisting the bristles of a flat-ended oil painter's hog brush into the damp blue paint. When this had dried to a sticky stage, I thumb-printed more black into it. For the woollen shawl I scribbled with the end of a sharpened stick, which had been tipped with thick black pigment, into a wash of diluted Black, using a circular motion.

345 x 90 mm (13½ x 3½ in)

Gypsy 2

Here, in contrast with the previous painting, I was particularly interested in colour. I also remembered the attraction of this dominant figure, leaning slightly back, with the head inclined and the arm and hand on hip making a strong triangular form. Notice how the angle of the top of the head reflects that of the lower arm.

Again, I saw the figure as a strong profile, dark against a pale background, but here there is more colour with the soft pink (very diluted Crimson Alizarin) contrasting with the green of the blouse. I deliberately emphasized the size of the basket, exaggerating it and making the rim sharp, edgy and pale, so that it stands out against the dark skirt.

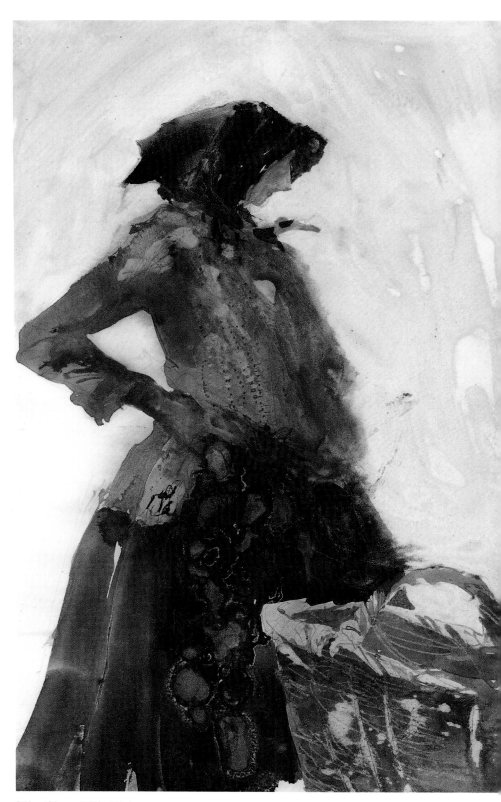

265 x 180 mm (10½ x 7 in)

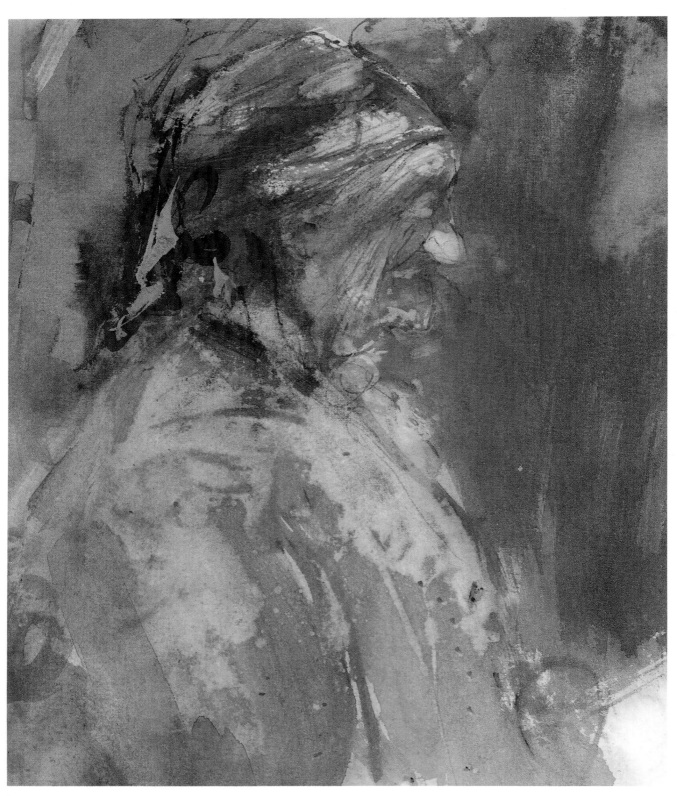

230 x 230 mm (9 x 9 in)

Gypsy 3 (left)
This old lady was impressive in her colourful clothes. I painted her dress with Cadmium Orange slightly greyed with residual paint that had dried in the palette lid, adding just one brush stroke of pure Cadmium Orange. The dress appears bright and strong against the background, which I painted with Phthalo Blue mixed with a little Hooker's Green. I tried to suggest a gentler concept of old age by using soft light and subtle tones. The lights in the face were softened by the washing-out technique.

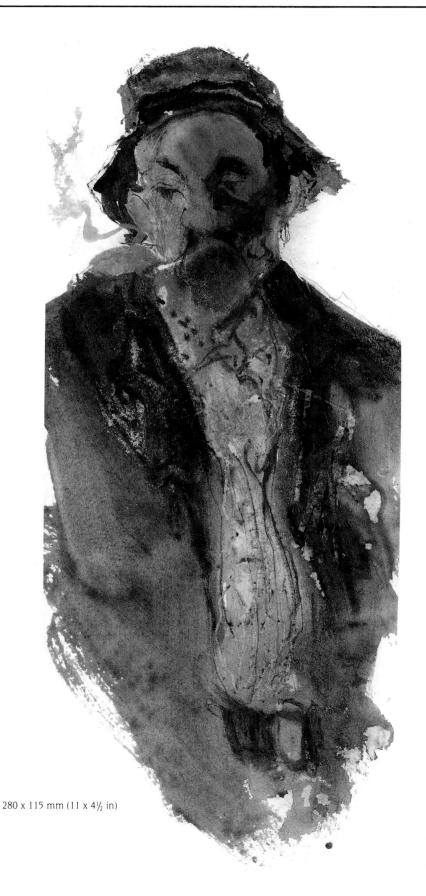

Gypsy 4 (right)
This painting was done with vigorous brushwork, painted mostly wet into wet, and took only a few minutes. I tried to capture the elements I remembered most vividly – the facial features, the curling smoke from the cigarette and, of course, the splash of Rose Madder colour in the careless neckerchief, contrasting brightly with the sombre Burnt Umber of the jacket.

280 x 115 mm (11 x 4½ in)

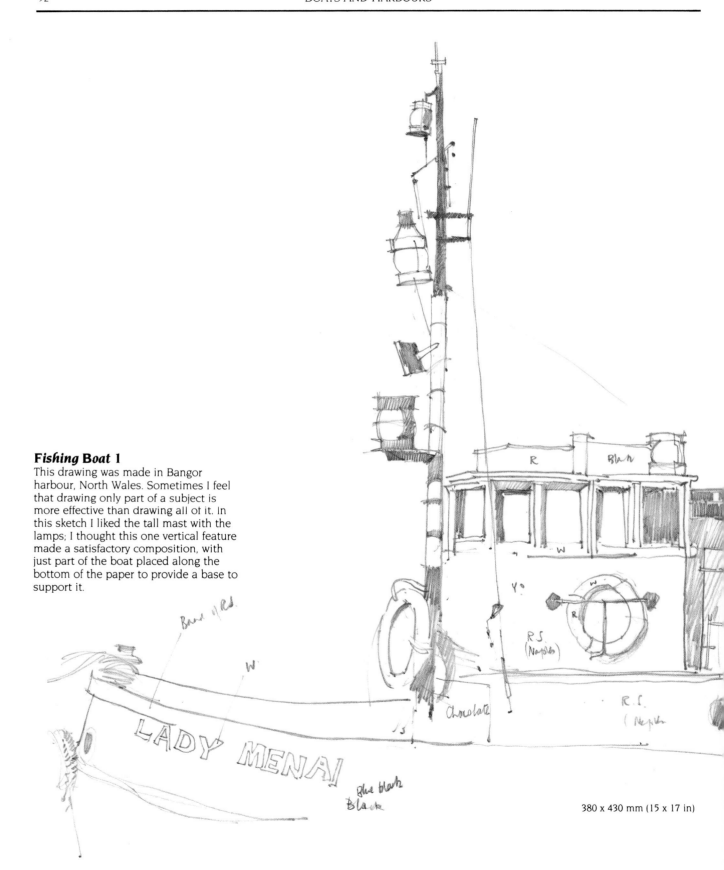

Fishing Boat 1

This drawing was made in Bangor harbour, North Wales. Sometimes I feel that drawing only part of a subject is more effective than drawing all of it. In this sketch I liked the tall mast with the lamps; I thought this one vertical feature made a satisfactory composition, with just part of the boat placed along the bottom of the paper to provide a base to support it.

380 x 430 mm (15 x 17 in)

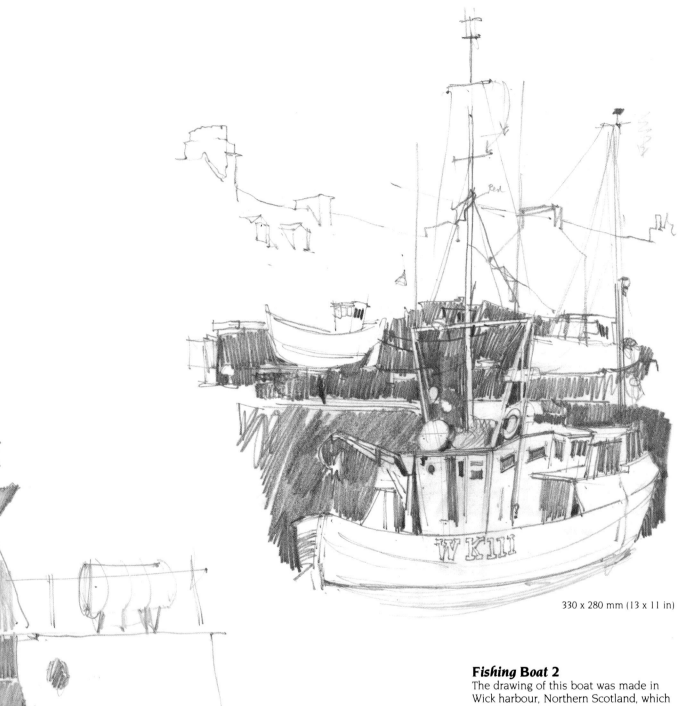

330 x 280 mm (13 x 11 in)

Fishing Boat 2
The drawing of this boat was made in
Wick harbour, Northern Scotland, which
was full of fishing boats and colourful
fishing tackle. The boat was moored
alongside the harbour wall, which I
indicated with dark pencil strokes. These
are useful in providing a dark back-
ground for the lighter tones in the boat.

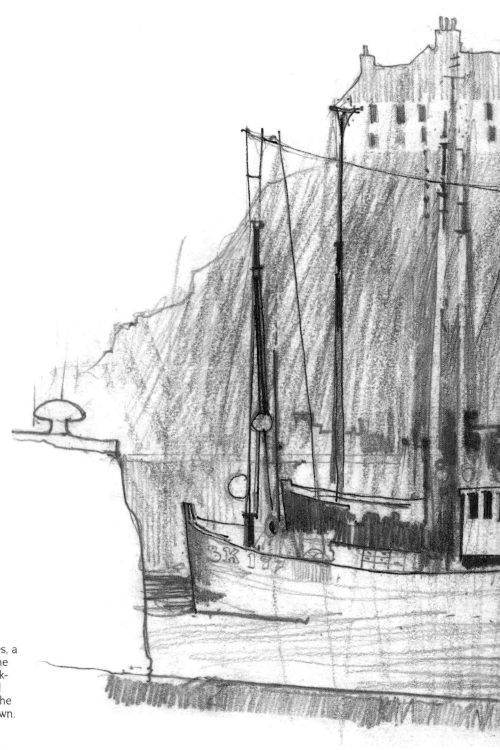

Fishing Boat 3

These boats were drawn at Seahouses, a fishing port in Northumberland on the north-east coast of England. The background again consists of quick pencil strokes vigorously applied, whereas the linework in the boats is precisely drawn. The dark blocks of the windows and details of the boat echo the rows of windows along the cliff and catch the viewer's eye.

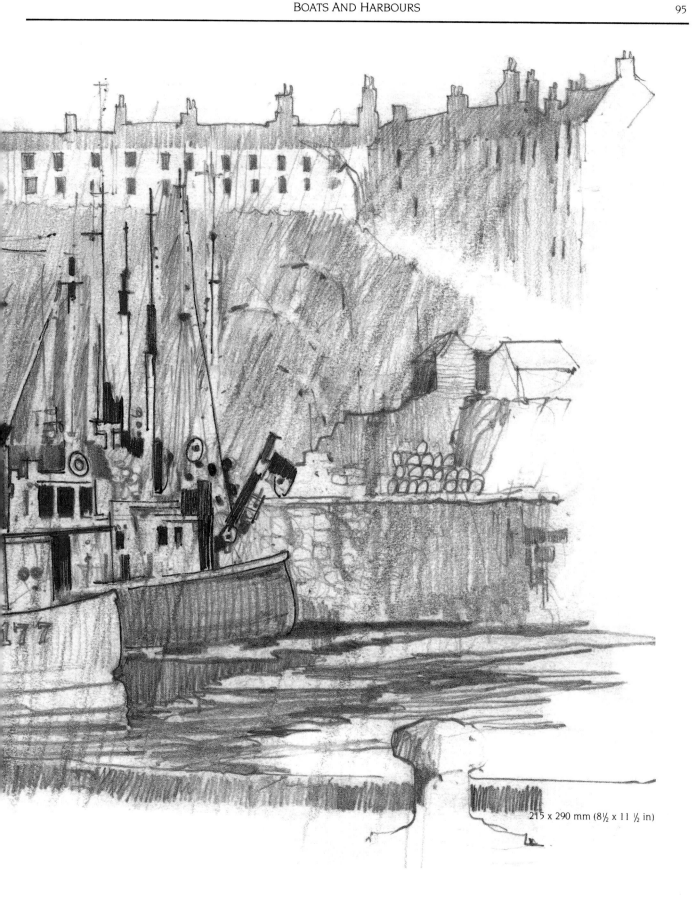

215 x 290 mm (8½ x 11 ½ in)

Polperro 1

Polperro, a one-time thriving Cornish fishing village, is a jumble of fishermen's cottages surrounding the harbour. I think the ones shown in this sketch make an excellent composition with the steps zig-zagging upwards and squeezing through the narrow gap between them. The inverted V-shaped area of sky is interesting in the way it slices down between the buildings. The cottage on the left is a strong, dark shape with its massive chimney against the sky. The cottages on the right were cream-coloured, with their roofs painted over with cement as protection against the weather.

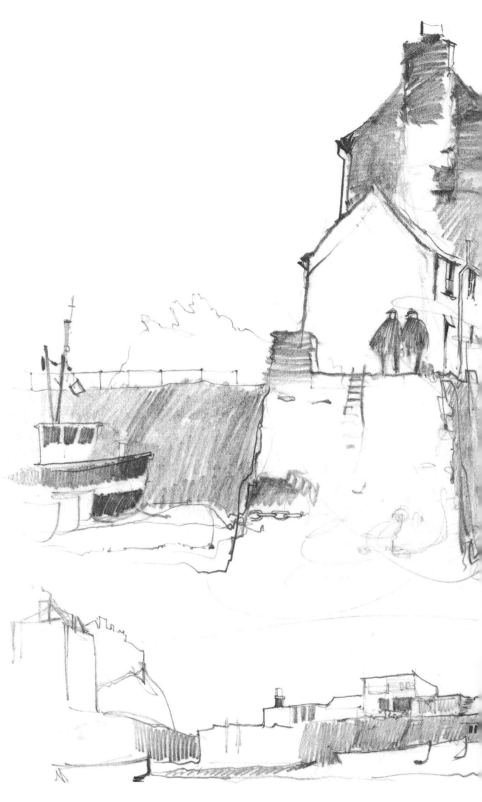

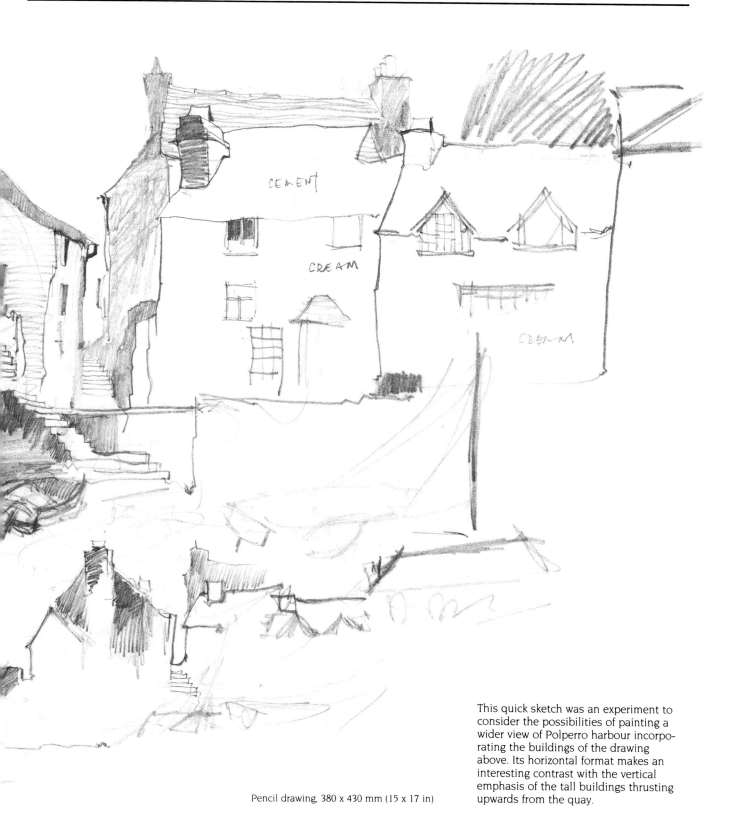

CEMENT

CREAM

CREAM

Pencil drawing, 380 x 430 mm (15 x 17 in)

This quick sketch was an experiment to consider the possibilities of painting a wider view of Polperro harbour incorporating the buildings of the drawing above. Its horizontal format makes an interesting contrast with the vertical emphasis of the tall buildings thrusting upwards from the quay.

Polperro 2

This drawing of Polperro shows the
harbour cottages and boats at low tide. I
was especially interested here in the
variety of architectural details – the
chunky chimneys and the solid shapes of
the fishermen's cottages – so I drew the
buildings with considered, precise
linework, all the heights, widths and
spacing carefully judged. The boats are of
secondary importance and are therefore
out of focus, drawn freely and sketchily
and containing just enough information
for future use.

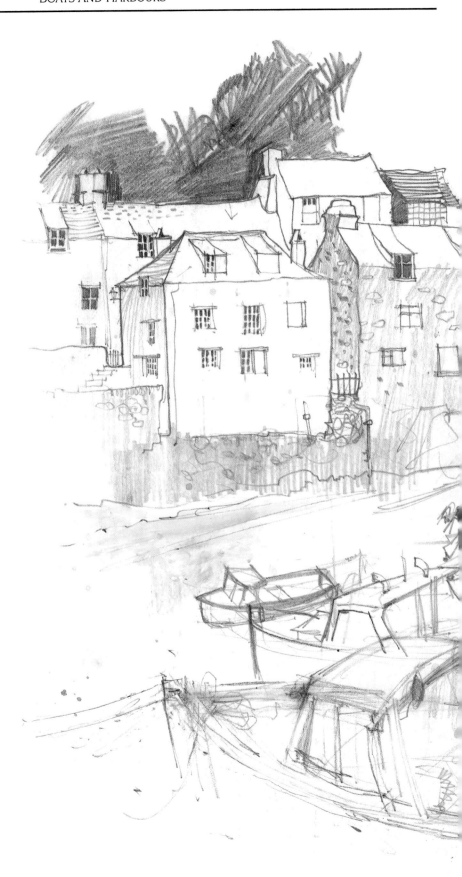

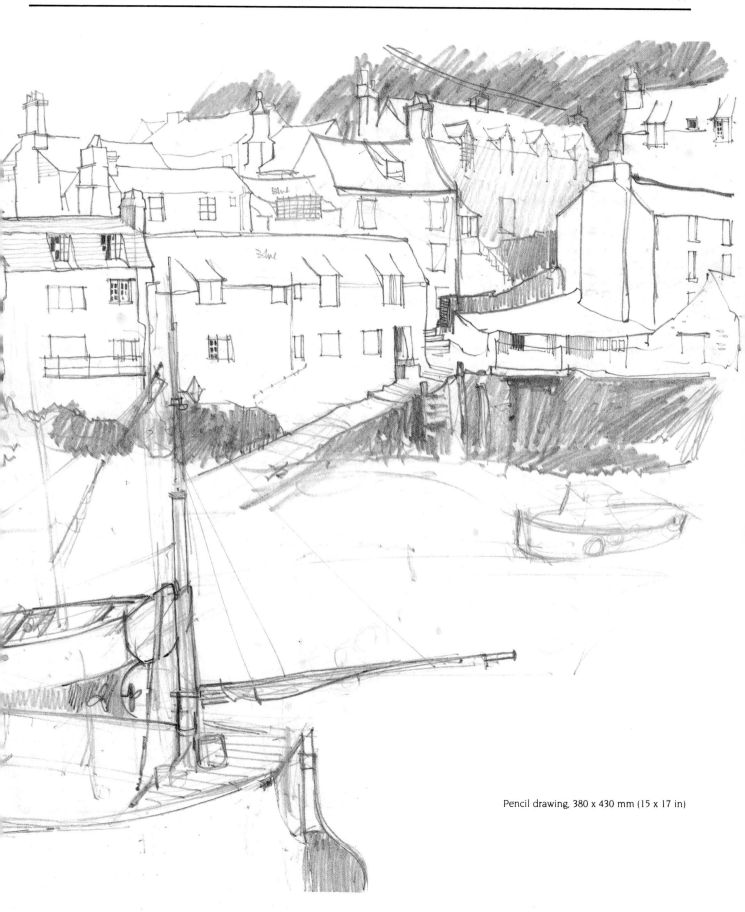

Pencil drawing, 380 x 430 mm (15 x 17 in)

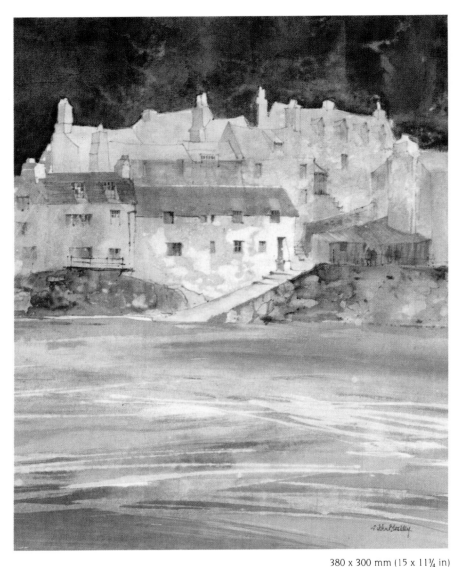

380 x 300 mm (15 x 11¾ in)

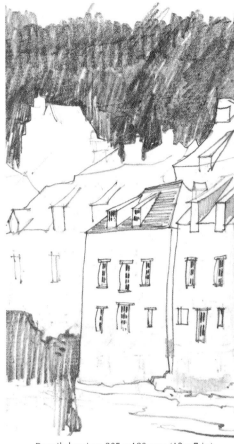

Pencil drawing, 305 x 180 mm (12 x 7 in)

Polperro 3

This painting is based on the previous sketch, but I chose to show the harbour at high water, with the tide about to turn. I remember the see-saw movements in the water at this time, as though it were poised and gathering momentum to flood through the narrow harbour entrance to the open sea.

The harbour sits in a deep ravine and the cottages are backed by tree-clad cliffs. Here, however, because I wanted to emphasize the interesting roof profiles of the cottages I deliberately omitted details of the trees and painted a dark background of Indigo, with traces of Sap Green added while wet. I kept all these roofs light in tone and similar in colour – very dilute Sap Green – so that the main colour and tonal differences are located in the nearer buildings and the sea. I lifted lines of dilute Indigo colour from the sea to create soft-edged streaks of light. To provide a unifying link between the buildings and the sea I subdued the whiteness of the central cottage by dappling it with blue-grey.

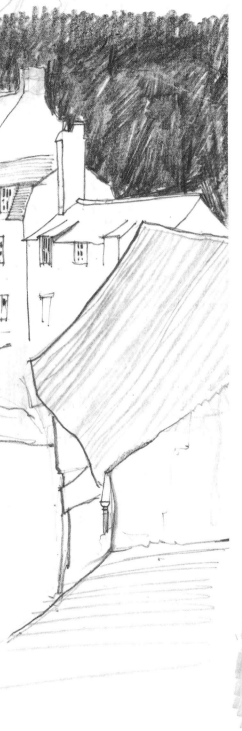

Polperro 4

This is another view of the cottages shown on pages 98–99 and opposite, but this time I sat on the harbour wall to get a more sideways view of them curving away from me. I gave the three central cottages slight emphasis by using strong line, by filling in the window panes, and by shading the roofs. These buildings stand in the water at high tide, but I have left the sea area empty so that attention is concentrated on the cottages.

Polperro 5

This drawing relies on contrasts for impact: the taut, precise lines of the buildings as against the broad, scribbled pencil work of the toned areas; and the whiteness of the cottages as against the darker shaded areas. The white parts of the boat echo the buildings, however.

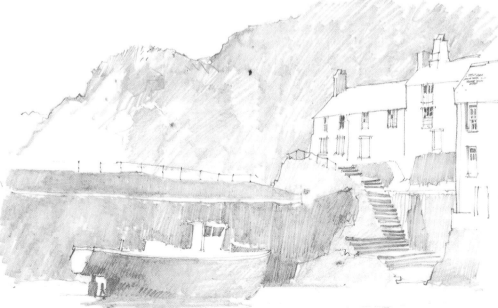

Pencil drawing, 140 x 215 mm (5½ x 8½ in)

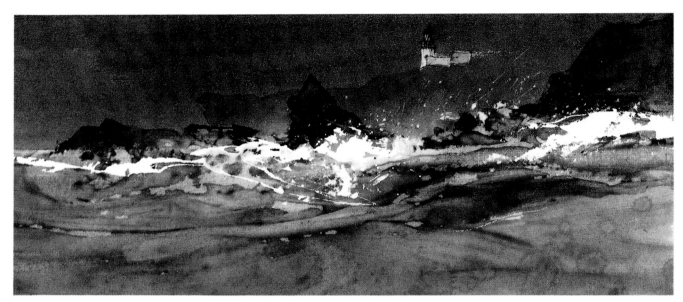

115 x 315 mm (4½ x 12½ in)

I FOUND Scurdie Ness, on the east coast of Scotland, on a cold and wet January day, but despite the weather it was tremendously exciting, with the noise of the sea unbelievably loud. The water cascaded over the rocks, heaving, boiling and, without warning, spewing spray so that the distant lighthouse was hidden. I slithered along a line of rocks and got wet for my troubles, but I did manage to make some sodden scribbled pencil notes. The watercolour sketches shown here were painted from these pencil notes, aided by memory. They were made as small experimental notes, on scraps of paper, in an attempt to recall something of my personal sensations of the day, and were not originally intended for publication.

Scurdie Ness 1

In this sketch I wanted to convey the heavy swell of the water, crested with white foam. The sky and distant headland were painted with simple, flat, dark washes of Payne's Grey to emphasize the whiteness and activity of the sea breaking around the pointed rocks. The grey-green sea in the foreground was painted relatively simply, with Hooker's Green greyed with Payne's Grey, using just enough brushwork to suggest its movement. When the painting was dry I used a sharp, pointed scalpel to gouge the paper surface and produce the flecks of foam. Used judicially, a scalpel or razor blade is very effective in obtaining flickers of light. I sometimes employ this method to obtain the impression of sunlight sparkling on water.

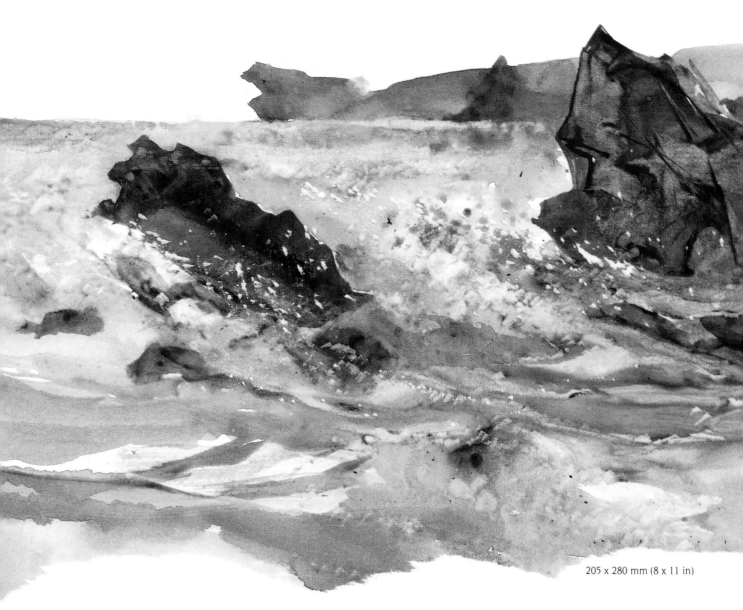

205 x 280 mm (8 x 11 in)

Scurdie Ness 2

Here I tried to suggest the water boiling and frothing as it rushed between the gap in the rocks. As in the previous painting the activity in the water is most pronounced around the nearer rocks, which were painted in Burnt Umber. I used dilute Indigo and Aureolin for the sea.

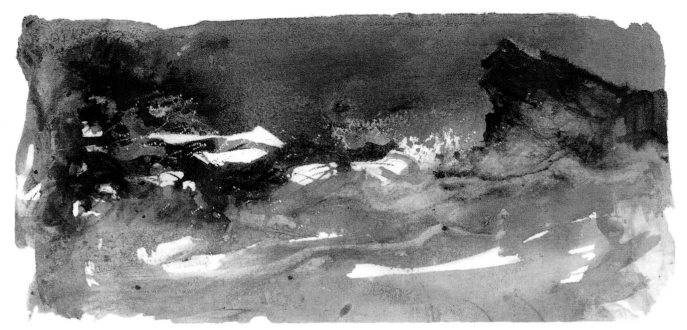

115 x 230 mm (4½ x 9 in)

Scurdie Ness 3

This sketch took the shortest time to paint. It was a sort of last fling, a hit or miss attempt, done in a few minutes, yet for me it recalls the cold greyness of the day more successfully than the other sketches. I used Lamp Black for the sky and rocks, and Lamp Black mixed with a little Lemon Yellow for the sea. The indefinite darks on the left of the painting suggest the turbulence of the sea, together with hints of spray. The hard-edged white parts provide sharpness and impact within the general softness of murky colour.

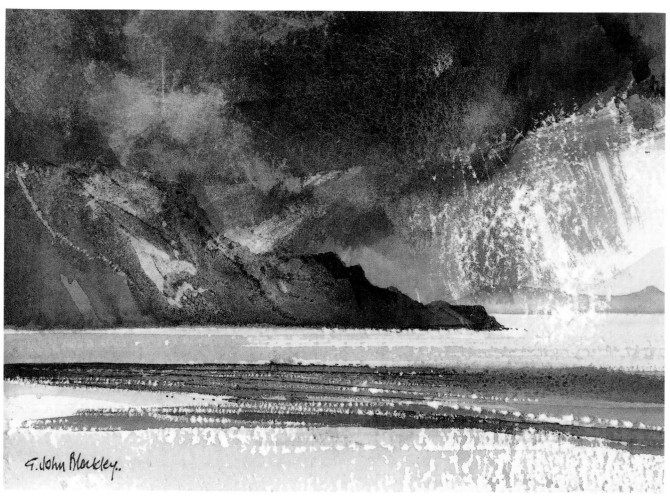

G. John Blockley.

Monochrome painting, 135 x 180 mm (5¼ x 7 in)

Seascape

This is another sea subject, but this time with mountains as well. It was painted with one colour, Indigo, ranging from very dilute washes to strong, dark mixtures. I wanted to give an impression of heavy storm clouds, with intense sun rays breaking through to cascade over the water surface. The glittering sparkles of light were made by very quick brush strokes across a Not surface paper. This is rough enough to break through the paint and leave highlights of white paper showing, yet sufficiently smooth to give continuous unbroken washes for the clouds at the top of the painting. Alternatively, a razor blade can be used to achieve a similar effect, as described for Scurdie Ness 1 on page 102.

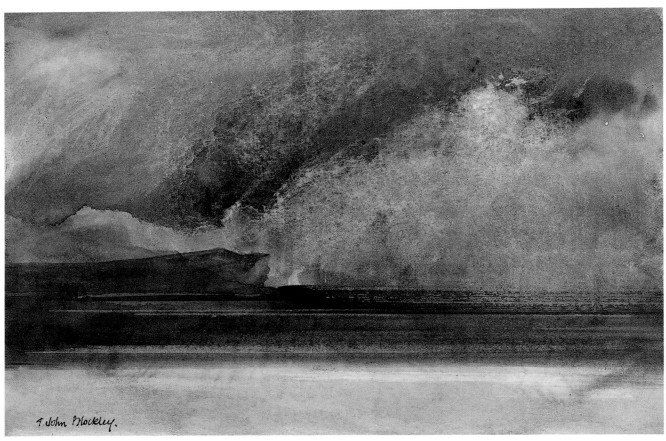

125 x 205 mm (5 x 8 in)

THE headland illustrated here is in Caithness, Scotland, and is the most northerly part of mainland Great Britain. I have painted here at all seasons of the year – on short days of winter and in summer when, at this northern latitude, the days are very long – and observed it in all weathers and moods. On good days the Orkney Islands can be seen across the treacherous water of the Pentland Firth.

Dunnet Head 1

This interpretation was painted in low key, and with only two colours to produce the moody, sullen impression of a cold grey day. I used Payne's Grey for the most part, mixed in places with small additions of Lemon Yellow to give a slightly greenish tinge. The sky was painted wet into wet, but with fairly hard edges here and there to provide slight relief from the heavy, lifeless blanket of cloud.

I took a very diluted wash of the sky mixture to the bottom of the paper and brushed light horizontal strokes into it so that the headland softly emerged. When the sea wash was nearly dry, I made rapid horizontal brush strokes across it with a worn, stiff-bristled oil painter's brush to create broken lines across the surface. I think these lines are important for they provide a change from the more usual atmospheric wet-into-wet treatment; in addition, they are the successful result of decisive, rapid brushwork and good judgement in determining the right moment to apply it. The paper at this particular moment was not quite dry with the result that the brush lines were very slightly softened. Had it been wetter, the lines would have been absorbed and lost; and if too dry, they would have been hard-edged and too assertive. Success with watercolour often depends upon one single action such as this.

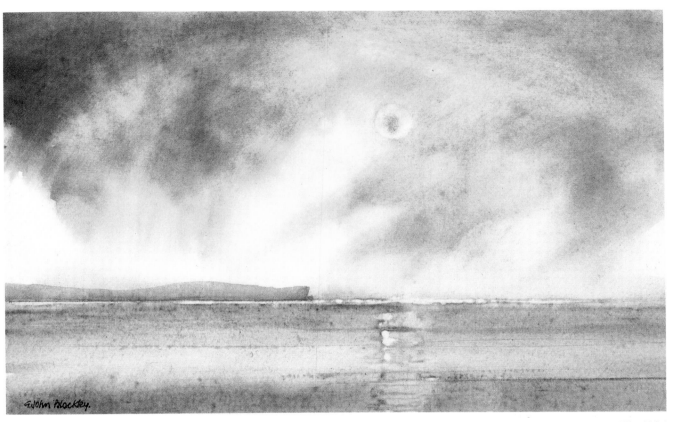

190 x 255 mm (7½ x 10 in)

Dunnet Head 2

This northern coast has spectacular sunsets. Artists marvel at them but are fearful of their paintings being too pretty and sentimental. I thought I'd try one, however, although I have subdued the brilliant reds and yellow that I actually saw and instead inclined to pink and orange. I let the white of the paper show through the washes by using only very dilute colour, in places almost pure water.

The painting was made using wet-into-wet brushwork, working the sky with mostly circular movement and dragging the paint downwards occasionally. The sea was painted with horizontal brush strokes into dampened paper. The setting sun, and its reflection, was lifted out with a just moist, clean brush. Finally, the headland was painted in – the only hard-edged feature in the painting.

This is essentially a traditional watercolour painted with transparent colour washes and relying greatly on the white of the paper reflecting through them.

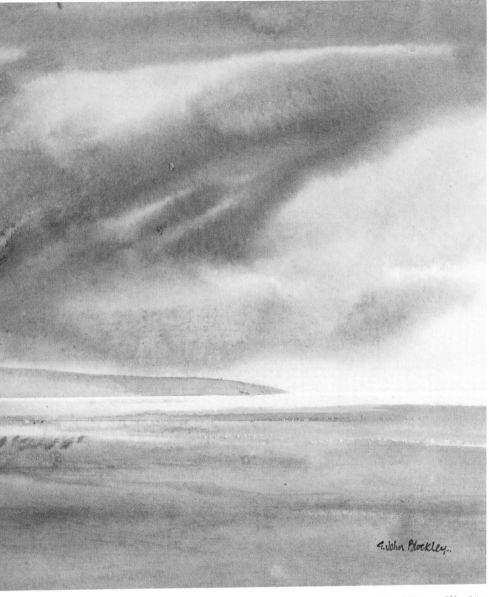

215 x 205 mm (8½ x 8 in)

Pembrokeshire Headland 1

I started this painting by making a very simple sketch of this headland in South Wales, just to register its shape (see below). This was one factual piece of information that I needed to record accurately. I felt free to interpret the other aspects of the subject as I wished.

The painting is principally concerned with the light in the sky and its reflection in the water. The important things to notice are that there are few hard edges and that the colour is restrained. These simple devices give more impact to the light parts of the sky. I used Payne's Grey for this, painted wet into wet to give a soft atmospheric effect, mixing in a hint of Cadmium Red to warm the grey slightly. The sea was also painted with Payne's Grey, mixed with Lemon Yellow. The headland, too, was painted with Payne's Grey, this time mixed with Cadmium Red, applied on dry paper to produce a hard-edged shape.

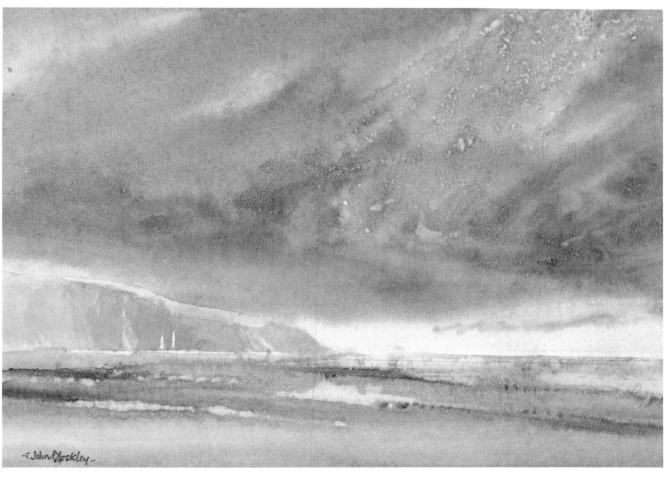

180 x 240 mm (7 x 9½ in)

Pembrokeshire **Headland 2**

In this painting I brought the headland forward and introduced a little colour. This colour change needed to be subtle; I used Cadmium Red, subdued by mixing it with Payne's Grey. A little of this warm colour, mainly used for the headland, is also reflected in the sky, although in general I tried to suggest a cold, grey, moody sky, almost oppressive. The sea, certainly, is cold, green and uninviting.

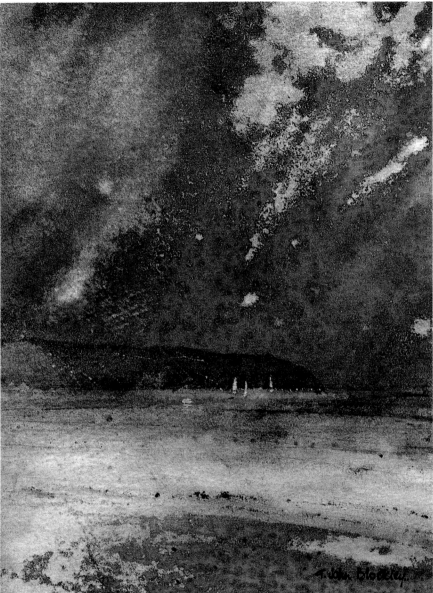

150 x 100 mm (6 x 4 in)

Pembrokeshire Headland 3

This is a stronger and perhaps more imaginative interpretation. Its main impact is in the use of rich blue colour, a mixture of Indigo and Phthalo Blue. I began the painting by washing blue all over the paper and then selectively washed out and blotted away the clouds and the reflected light in the water. The headland, which is secondary to the effect of shimmering light on the sea, was painted last.

The painting is simple, contains basically one colour, and uses contrasts of light against dark to achieve its main purpose. The important point this illustrates is that one should start with a specific idea and relate the painting techniques to that idea.

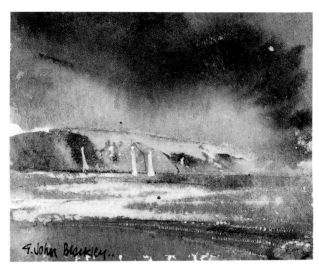

70 x 80 mm (2¾ x 3¼ in)

Pembrokeshire Headland 4

I enjoy making small, intimate little paintings like this. The headland is bathed in light, which brings out the pink of the cliffs, and the halo of light around them spreads outwards into the inky blue of the sky. The softness in the sky was achieved by using the normal wet-into-wet techniques. The zigzag of light furrowing through the water leads towards the land and was obtained by blotting out. The sails of the boats were flicked in with a small brush, using an opaque white gouache. I used Cadmium Red for the cliffs, Indigo for the sky, and Indigo mixed with Hooker's Green for the sea.

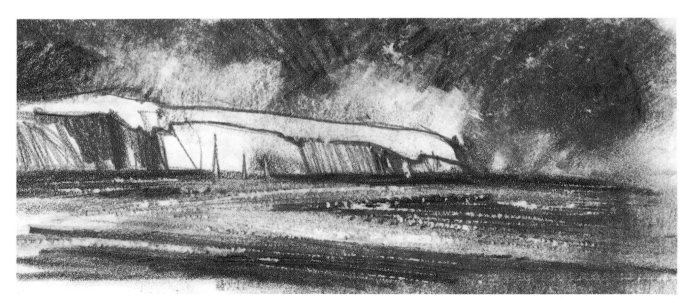

Charcoal sketch, 75 x 180 mm (3 x 7 in)

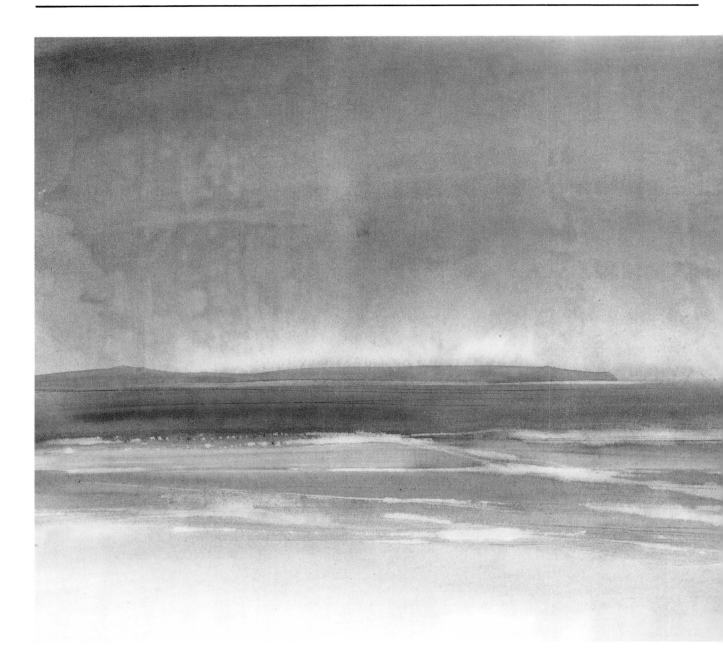

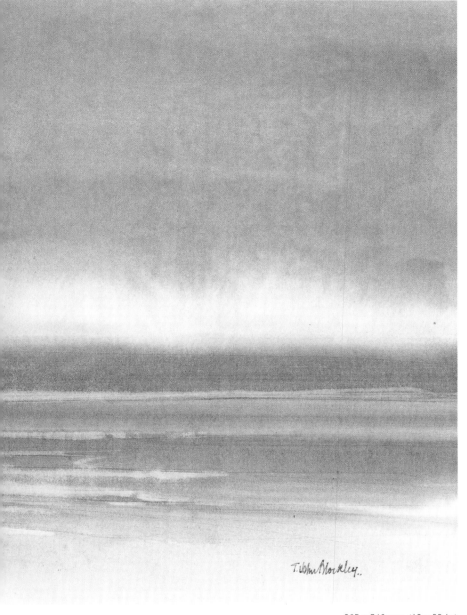

Pembrokeshire Headland 5

Here I tried to suggest a moisture-laden sky, with light appearing at the horizon. In fact, the sky is shedding some of its moisture and this drifts downwards across the band of light. The distant passage of dark blue sea is important in emphasizing the light in the sky, and its softness at the horizon helps to convey the damp, atmospheric nature of the day. I used two colours only: Indigo for the sky and most of the sea; and Indigo with Aureolin for the hints of green in the water.

The light passages in the water are intended to suggest lethargic movement and their slightly angular directions are useful as a foil to the predominantly horizontal brushwork in the rest of the painting. The headland was painted last as a flat, hard-edged shape, silhouetted against the soft light in the sky. The slick of light at the tip of the headland is an important sharp accent and helps to attract the eye to this distant part of the scene.

305 x 560 mm (12 x 22 in)

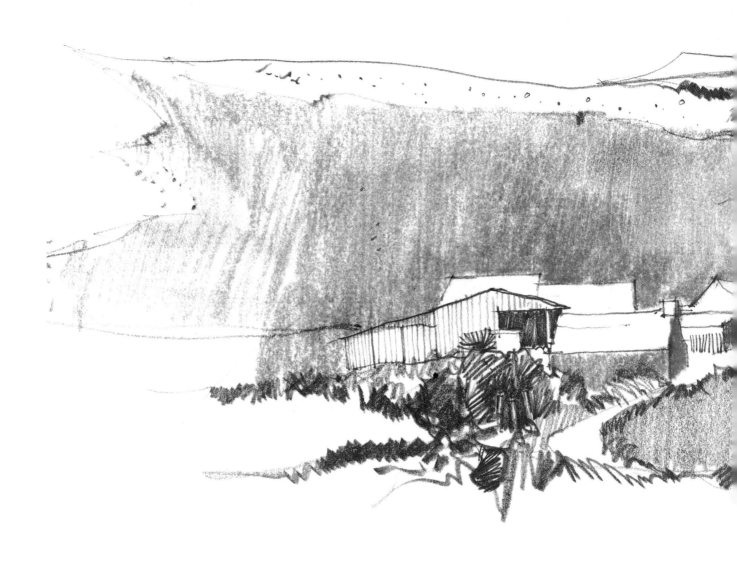

Trefelli, Pembrokeshire

This part of Pembrokeshire in South Wales is dominated by a long ridge of hills along which a number of farms are scattered. I was attracted to this particular farm by the arrangement of its buildings stretched across the hillside and by the road leading away from me towards the house and then climbing almost vertically up and over the hill. I liked the simple white shape of the house and the way its dark windows looked straight at me. The severity of the vertical road, bisected by the horizontal row of buildings, is relieved by the sharp curve in it. The way the road in the foreground disappears and then reappears suddenly makes for interest.

In this drawing I treated the hillside as flat areas of pencil shading and confined the busy dark lines to the hedges.

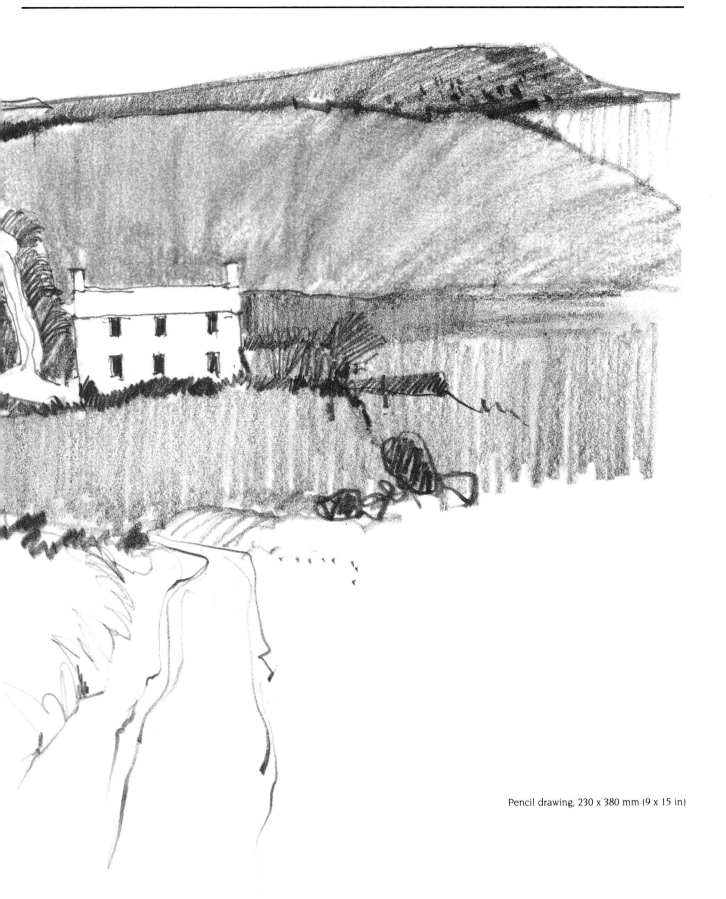

Pencil drawing, 230 x 380 mm (9 x 15 in)

Trefelli 1

This is a fairly literal representation of
the scene I remembered: light buildings
against a darker background, and a light
foreground. This arrangement sets off the
buildings well. The brushwork in the
background curves downwards, following
the contours of the hill, and so, for
contrast, the foreground is treated as a
fairly simple flat wash. The darker green
is Hooker's Green mixed with Payne's
Grey, and the light foreground colour is
Aureolin, also greyed slightly.

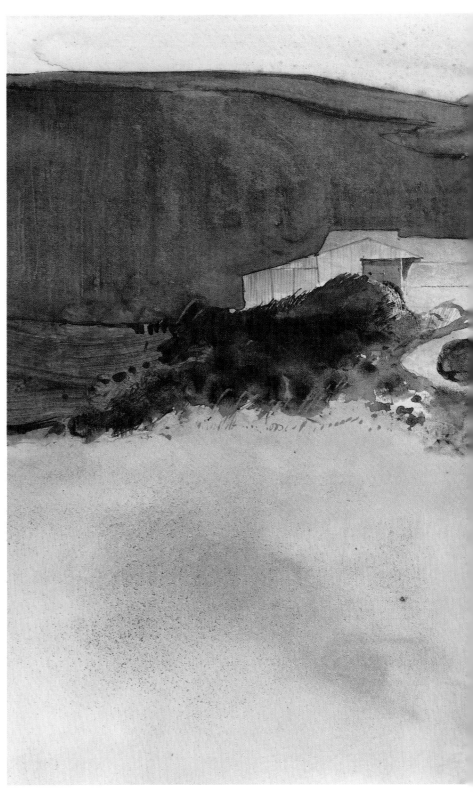

280 x 405 mm (11 x 16 in)

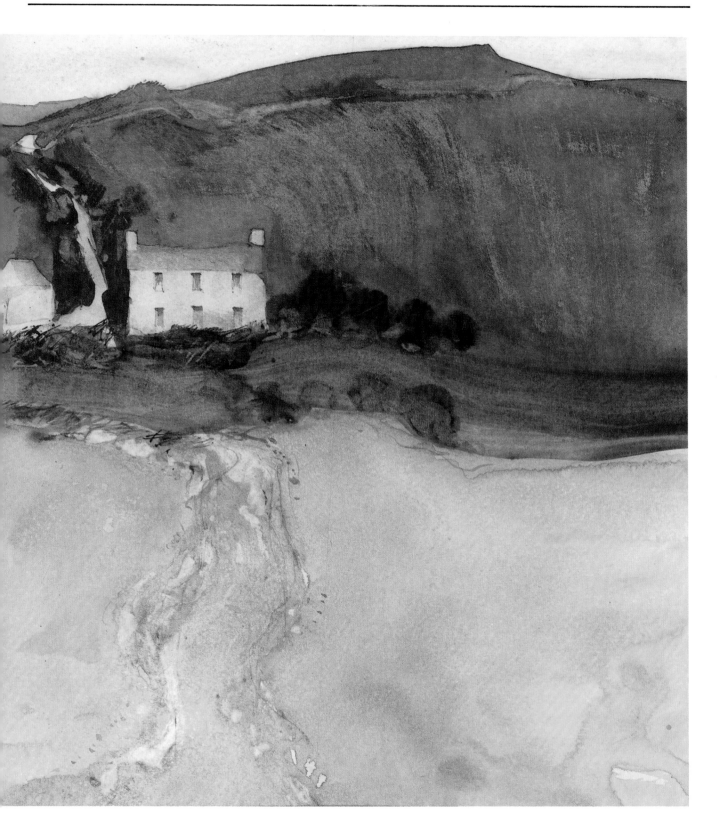

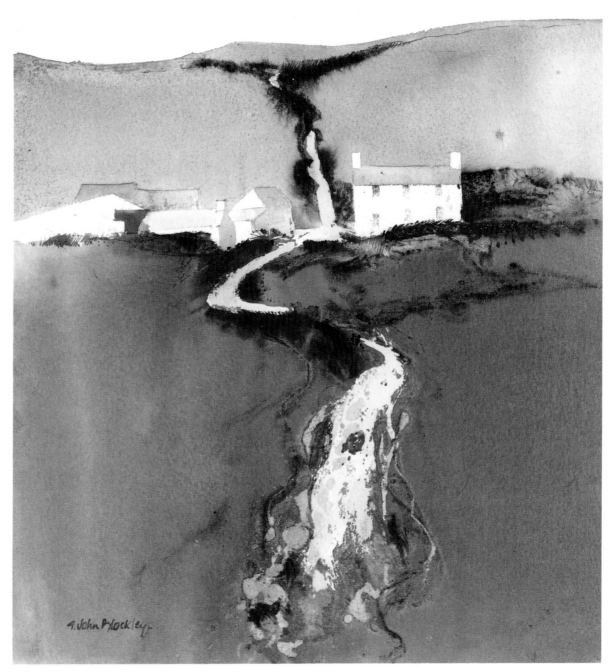

290 x 255 mm (11½ x 10 in)

Trefelli 2

Here I have let my imagination work a little more. The tonal scheme is reversed so that this time the background is light and the foreground dark. I painted a light green wash of Aureolin mixed with a little Indigo over all the paper. I added no more colour for the hillside, but the foreground was overlaid with a wash of Indigo. The vertical and horizontal arrangement of the hedges is emphasized here by making them very dark and contrasting them with the light buildings and the pale road winding between them. I was tempted many times to darken the foreground road slightly, but to have done so would have weakened the impact and the idea behind this particular interpretation.

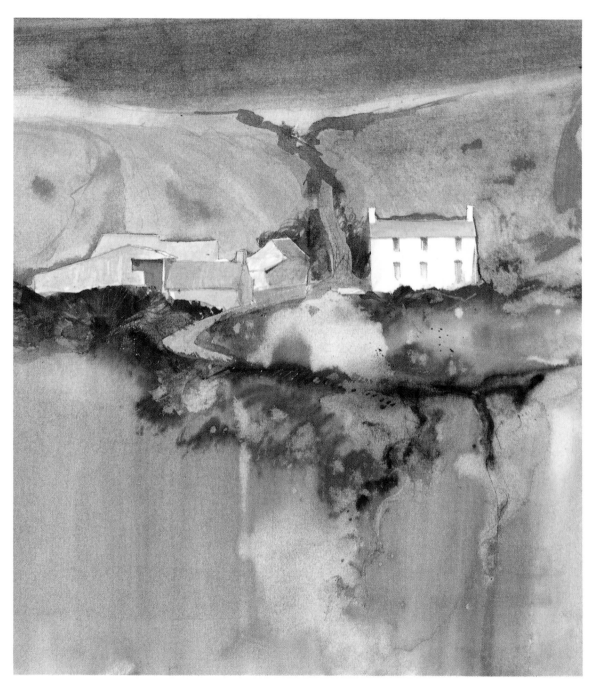

290 x 255 mm (11½ x 10 in)

Trefelli 3

Here I attempted to break down the formal pattern of road, hedges and contrasting tones by using random, soft, wet-into-wet brush strokes. The cottage is the only white part of the painting; it is hard-edged and contrasts with the muted colours and softened edges of the rest of the painting. The sky was painted with Phthalo Blue, slightly subdued with grey. Aureolin, slightly greyed, was used for the hillside, and the darker greens were obtained by mixing Phthalo Blue with Burnt Umber. There are also traces of Burnt Umber, very diluted, in the foreground.

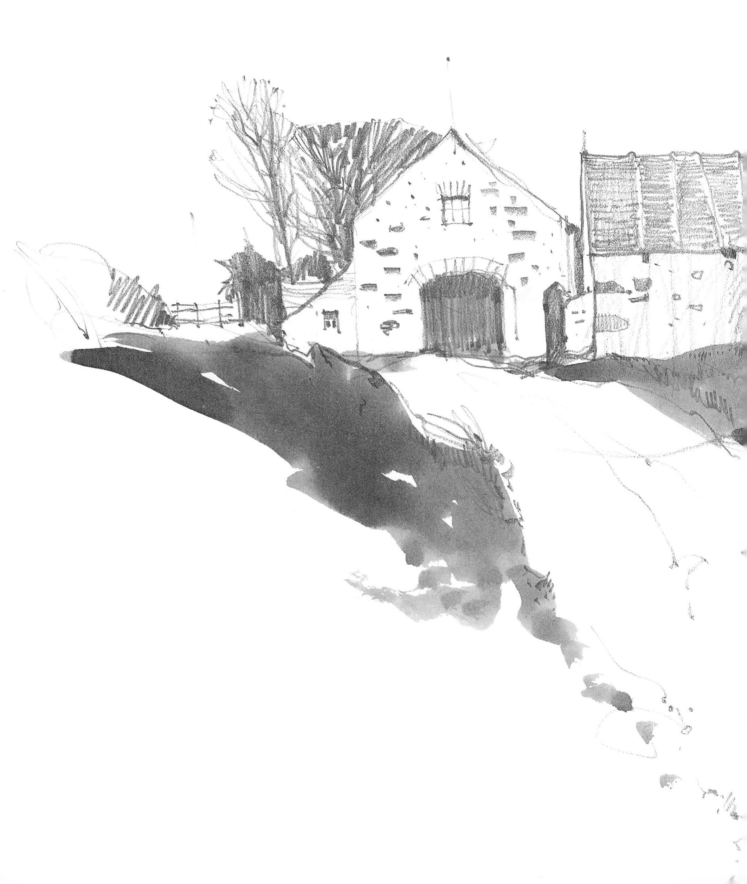

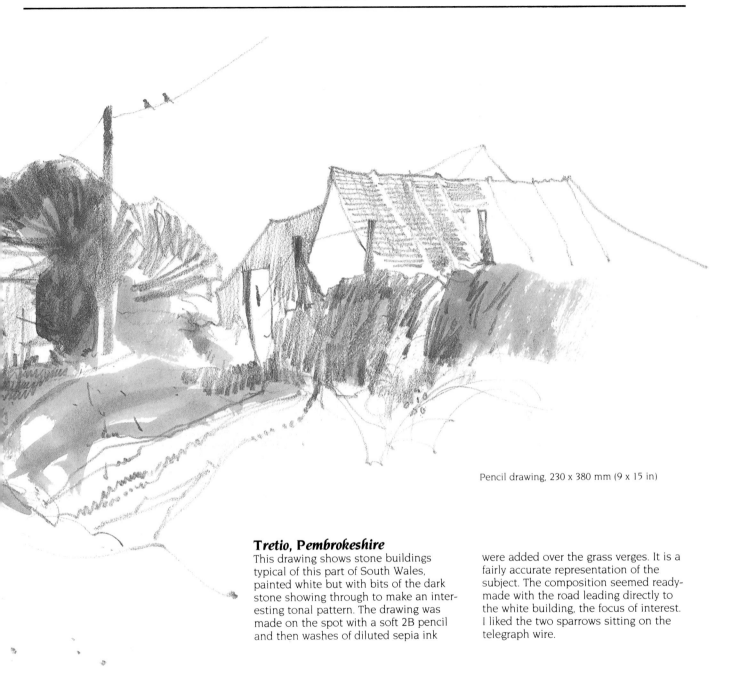

Pencil drawing, 230 x 380 mm (9 x 15 in)

Tretio, Pembrokeshire

This drawing shows stone buildings typical of this part of South Wales, painted white but with bits of the dark stone showing through to make an interesting tonal pattern. The drawing was made on the spot with a soft 2B pencil and then washes of diluted sepia ink were added over the grass verges. It is a fairly accurate representation of the subject. The composition seemed ready-made with the road leading directly to the white building, the focus of interest. I liked the two sparrows sitting on the telegraph wire.

280 x 355 mm (11 x 14 in)

Tretio 1

Like the drawing on the previous page, this painting is designed to focus attention on the white building, so I left white paper for this and slightly tinted all the other light areas. The road is given some importance and helps to lead the eye to the building. The drawing of the trees is fairly precise and the linework in the branches provides a hint of contrast with the simple mass of the white building. I purposely left significant areas of the foreground empty so that attention focuses on the textured road and buildings.

I used Phthalo Blue and Black for the sky with the clouds washed out while it was still wet. The building and the road were basically painted with one wash of Cadmium Red, modified with some of the sky wash.

Tretio 2

Again the whiteness of the building is
emphasized, this time by enclosing it in
dark tones – Indigo in the sky, and Indigo
and Burnt Umber in the foreground. The
tonal pattern of the painting was
carefully worked out before I started to
paint. The triangular shapes of the two
white buildings echo each other within
the large area of dark, and the light
telegraph pole echoes the vertical direc-
tion of the ruts in the road and at the
same time provides a vertical foil to the
horizontal row of buildings. I think the
telegraph pole is an important element
in the painting so I increased its signifi-
cance by giving it greater prominence
than it had in the initial drawing I
achieved this by letting it disappear
straight out of the top of the painting.

190 x 330 mm (7½ x 13 in)

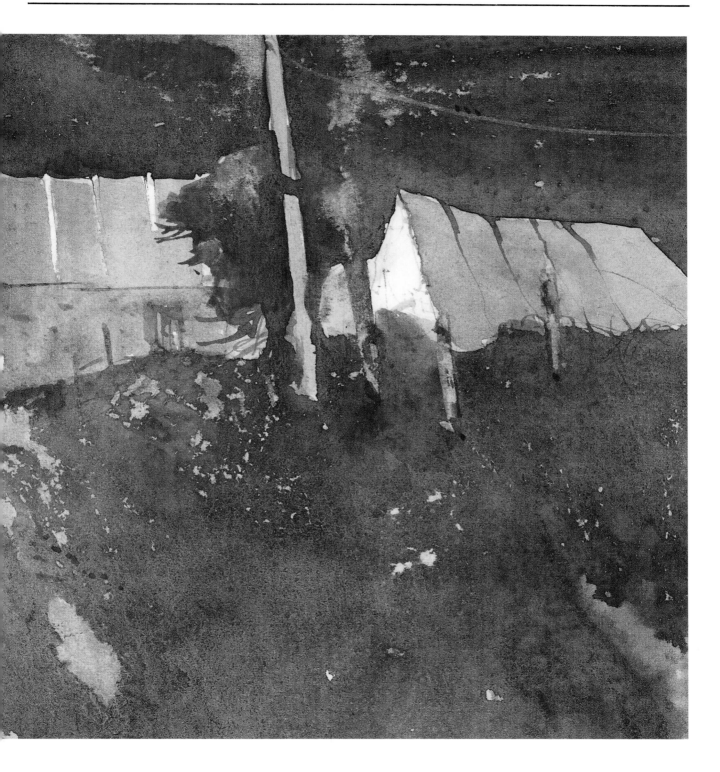

Pembrokeshire Cottage

This was drawn with a soft black graphite pencil, with grey conté pencil scribbled over the field and the ridge of grass growing along the middle of the rough track. The use of two types of pencil produces an interesting tonal effect and contrasts with the finely drawn, sinuous lines of the track.

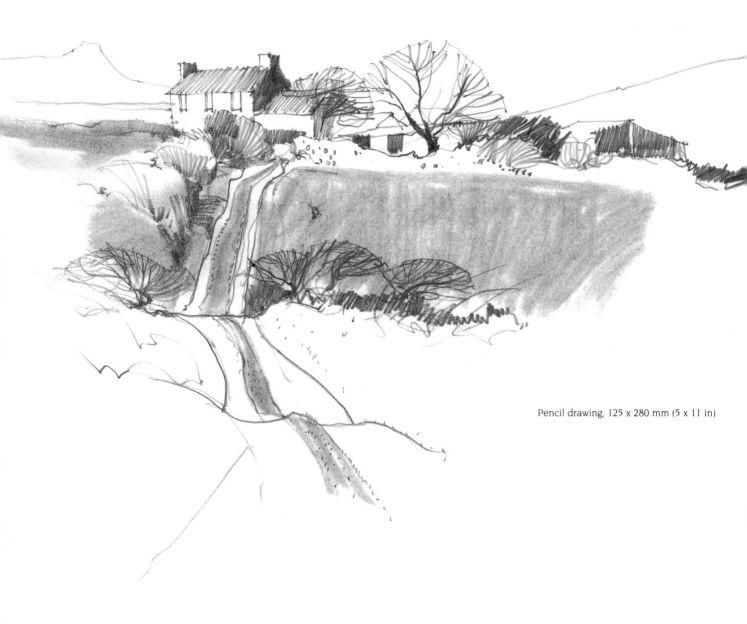

Pencil drawing, 125 x 280 mm (5 x 11 in)

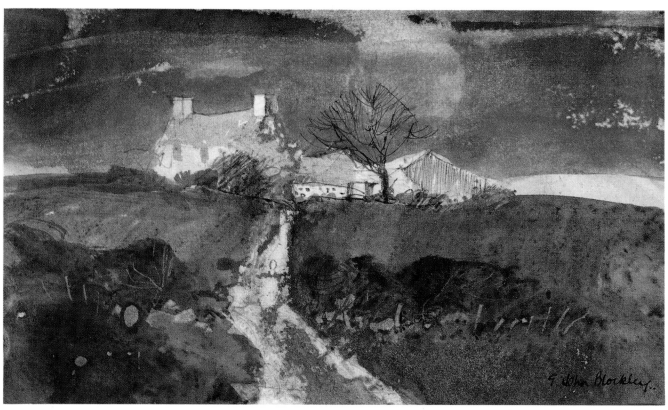

165 x 255 mm (6½ x 10 in)

Pembrokeshire Cottage 1

I decided a colour plan before starting to paint this picture, although I don't always do this. Sometimes I start a painting impetuously, usually working at breakneck speed, with a definite idea in mind but not actually planned, so that the painting develops itself – one brush stroke prompting another, one accidental blot suggesting a change of emphasis.

This is a bit of a hit and miss way of working but the fun of doing it is perhaps more important than the result. Consequently I throw a lot of paintings away!

My idea here was to integrate track and cottage so I painted them both in a light colour and similar in tone. The track is sandwiched between areas of grey – made with Payne's Grey and Burnt Umber – which has the effect of leading the eye between these surrounding dark areas to the cottage. Some of this grey was also used in the sky, but the rest of the sky is Cadmium Orange – the only real colour in the painting. The grey in the sky is intended to unify it with the foreground and to provide a sombre support for the orange.

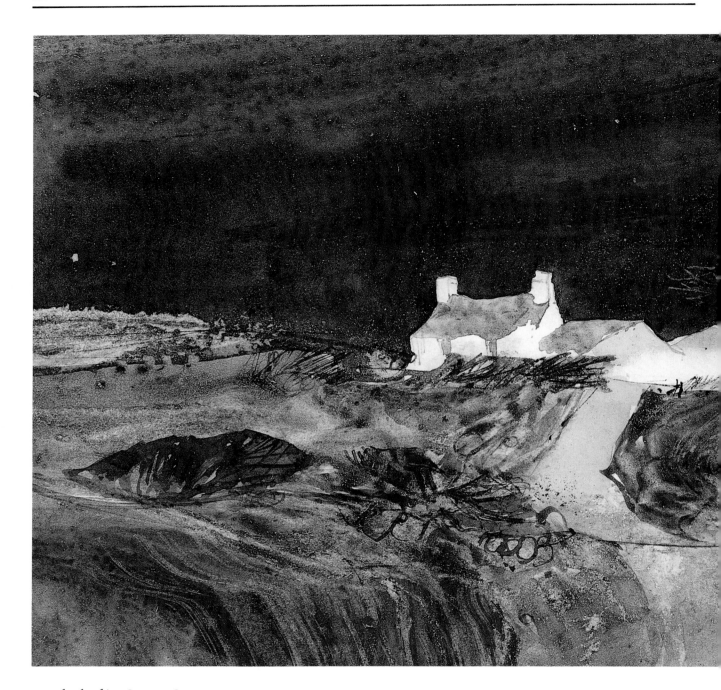

Pembrokeshire **Cottage 2**

This painting is based on the drawing on page 126 but with some adjustments, or exaggerations perhaps, to the buildings and track. I made these changes to help convey my impression of a simple, solid-looking cottage in contrast with the very textured foreground. The cottage is a clean-cut block whereas the landscape is fragmented with large boulders and stones, rough growth and windswept bushes. There are some patches of ground between broken walls which are ploughed and are used mostly for growing potatoes.

I have emphasized the white cottage by making the top of the painting dark.

The simplicity of this dark wash also contrasts with the textured, busy foreground. The choice of this dark tone was a considered tactic to help me portray these two ideas. I do not think of it as sky, or background; it is just dark paint! Even so, I have tried to inject a hint of variation within it to prevent

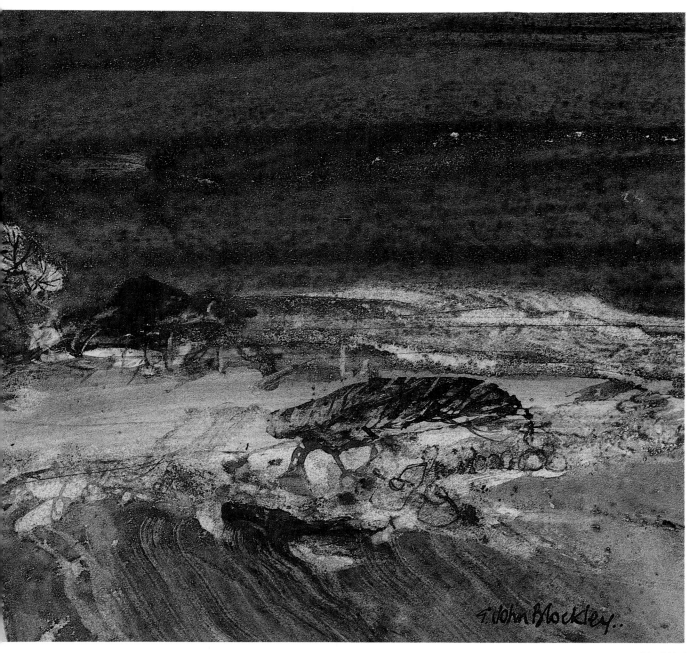

165 x 355 mm (6½ x 14 in)

monotony – a trace of red and a little streakiness in the brushwork. To create this effect I began by covering the top half of the painting with Crimson Alizarin, shaping it around the buildings. Then, when this was dry, I painted over it with a dark wash of Indigo mixed with a little Black. This produced a glazed effect with blushes of red showing through.

The tempo of brushwork changed for the foreground. I slashed the colour onto the paper using an old, splayed-out, long-bristled oil painter's brush to create striations of paint. In other parts I lightly blotted the paint to produce a finely grained, stippled surface, assisted here and there with a few deft thumbprints; but you won't find them because I immediately eased away the more obvious whorls of paint with a damp brush. I used Cadmium Red, slightly greyed, overpainted in places with Indigo.

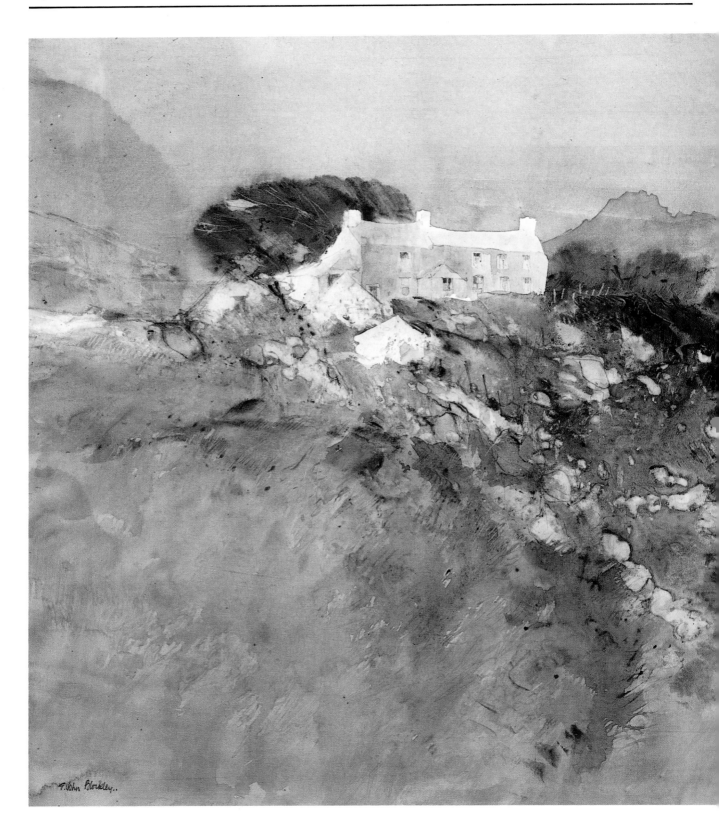

F. John Blockley..

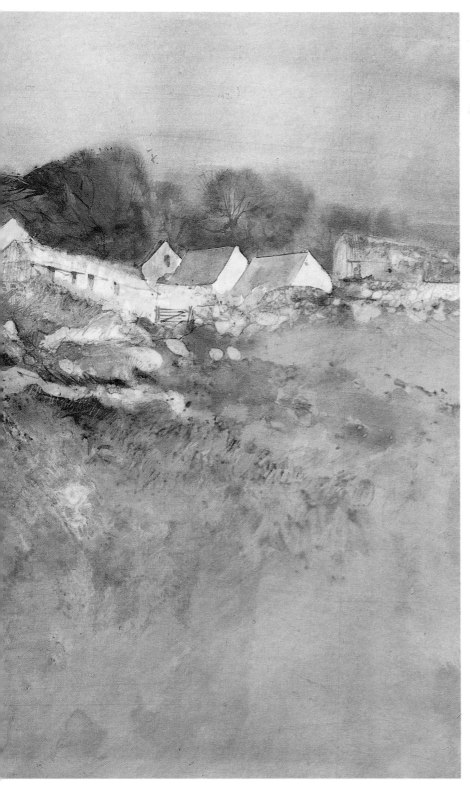

Cae Lem 1

Cae Lem in Pembrokeshire, South Wales, has long been a favourite place of mine and I have painted it close up, from a distance, and from the rocks above, looking down on it.

This painting was made in the studio from drawings, aided by memory. I remembered light falling onto the buildings, as well as being reflected from the stones and boulders that covered the ground, and I knew that I could best hope to achieve these effects by working in the studio where I had facilities for washing out. Most of the foreground lights, therefore, were obtained by blotting away colour while it was still damp and even by washing it away while the painting was completely immersed in a bath. The foreground grasses were achieved by a combination of removing and adding colour: the light strokes were lifted out while wet with a fine brush or the end of a painting knife, and darker strokes flicked in with brush and watercolour were then interspersed.

I had visualized the scene mainly in blue, so I began by applying a wash of Phthalo Blue slightly greyed with Payne's Grey over almost all the paper, but leaving white shapes for the buildings. Then I darkened the wash in places with a stronger mixture of the same colours, inclining the blue towards green in other parts by introducing touches of Aureolin. Finally, the farmhouse was stained with a weak mixture of Crimson Alizarin modified with Payne's Grey.

510 x 760 mm (20 x 30 in)

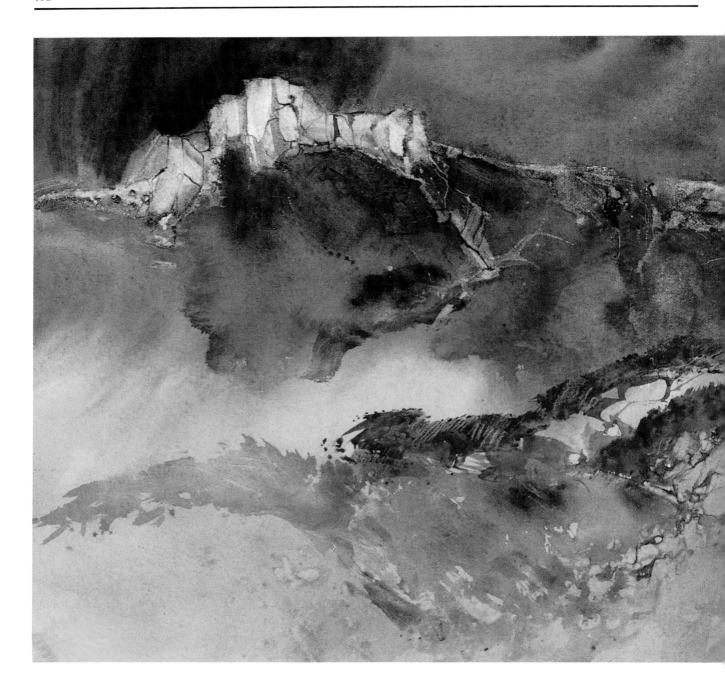

Cae Lem 2

In this interpretation I was interested in the rocky background more than the farmhouse. The silvery slabs of rocks have always appealed to me. I started the painting by carefully drawing the profile of the rocky ridge. I like to keep preliminary drawing to a minimum, however, so that I can flood colour onto the paper and develop the painting without being inhibited by detailed pencil lines. With the profile established, I washed Indigo over the sky area and continued the wash downwards to the bottom of the paper, changing the colour to green in the process by adding Hooker's Green to the Indigo. I ignored the drawing as I did this, simply washing the colour over it; but almost immediately afterwards, with the wash beginning to dry, I blotted out the light shapes of the rocks and the farm building. This produced the soft-edged profile of the rocks and left the paper slightly stained by the first wash, suggesting the silvery

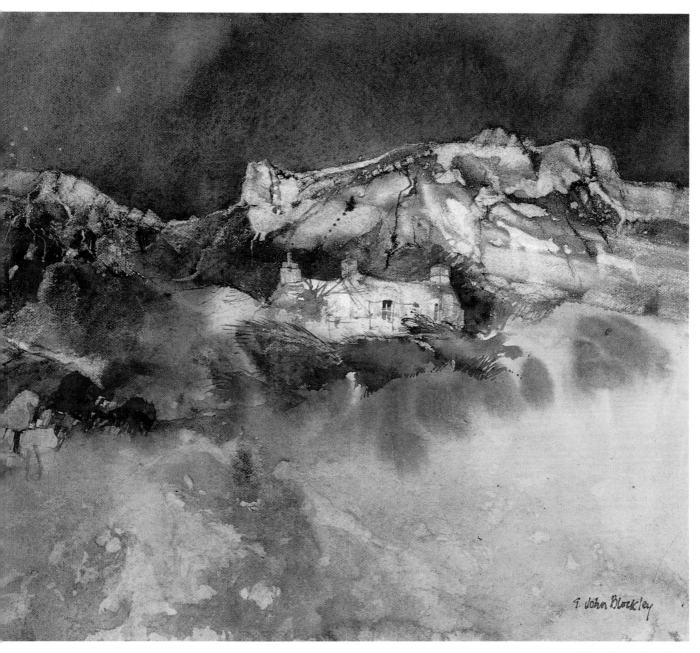

330 x 635 mm (13 x 25 in)

tints in them. The remaining dark blue blotches in the rocks are the unblotted parts of the first Indigo wash. I prefer this technique to painting the sky carefully around the ridge of rocks. The blotting-out process gives a feeling of continuity, of sky and rocks blending, with highlights of silvery rock appearing.

The foreground contains a few blotted patches, too, some of which have added linework to distinguish them as rocks within the grass. The process of blotting also allows you to leave a light shape softly edged, or gives you the opportunity to sharpen the edges selectively by drawing or with further colour washes.

The cottage here is an example of this: a little Indigo behind the chimneys tightens them and gives them definite form. A little added drawing also helps.

The middle distance consists mostly of wet-into-wet brushwork, using Burnt Umber. This conveys the idea of bushes and trees without actually defining them.

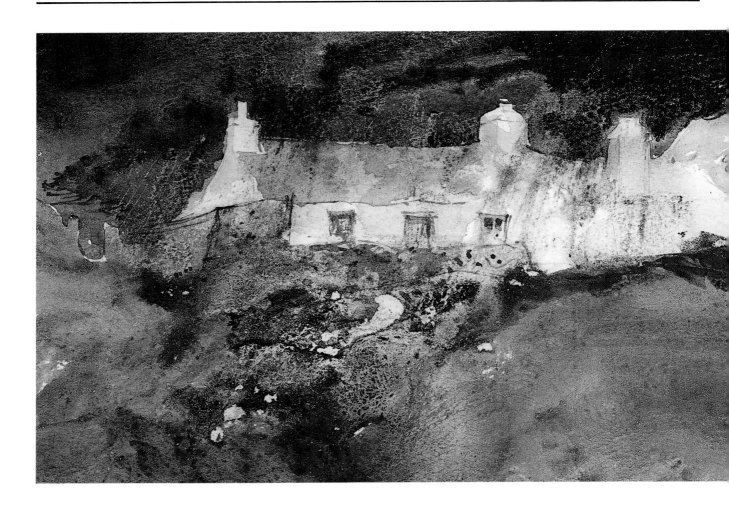

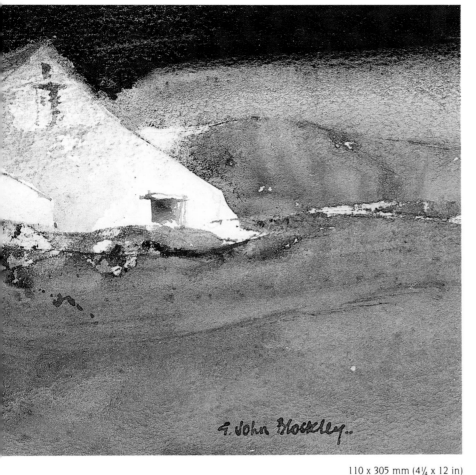

110 x 305 mm (4¼ x 12 in)

Welsh Cottage

I am always attracted by the simple architecture of the cottages in Wales: solid shapes, with chunky chimneys, no ornamentation, simply honest, functional buildings. The shape of this particular building appealed because of its single-storey construction, long and low, the irregular spacing of its chimneys, and the large pointed gable end of the attached barn thrusting forward. The stone wall of the building was especially interesting – silver light against the dark sky.

In the painting I selectively sharpened some parts of the building – the chimneys and the pointed gable – by controlled brushwork, but elsewhere I slightly blurred the edges with less precise brushwork, sometimes dragging a worn oil painter's brush across them while they were still damp.

I kept the foreground simple except for the indication of a road which gives a lead into the painting. I used Indigo and Black for the sky, also introducing some of this colouring into the foreground. The sombre green areas were painted with a mixture of the sky wash and Burnt Umber.

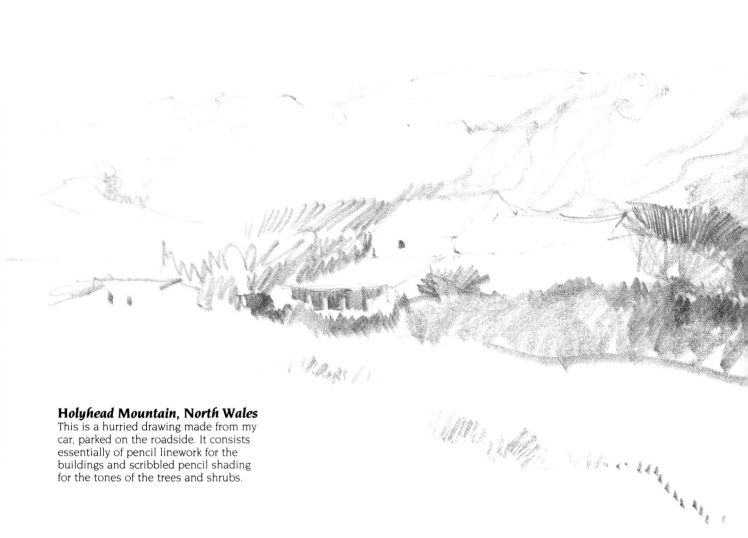

Holyhead Mountain, North Wales
This is a hurried drawing made from my
car, parked on the roadside. It consists
essentially of pencil linework for the
buildings and scribbled pencil shading
for the tones of the trees and shrubs.

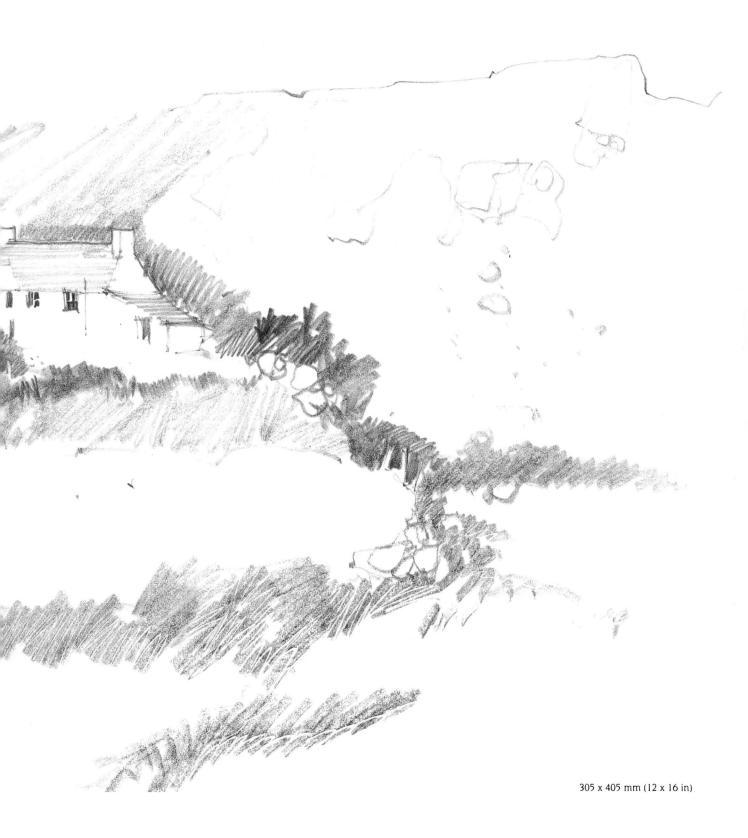

305 x 405 mm (12 x 16 in)

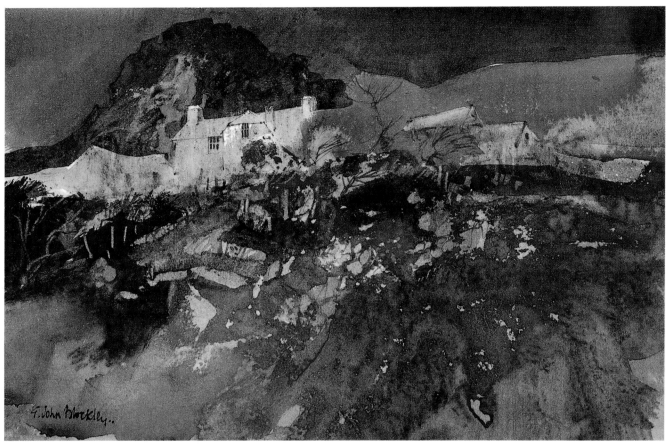

180 x 255 mm (7 x 10 in)

Strumble Farmhouse 1

This was painted on the spot in Pembrokeshire. The farmhouse sits on a plateau high above the road and with a rocky outcrop above it. I interpreted the house as a precise geometric shape placed, for contrast, against a foreground of random shapes, some of which were blotted out, some washed out but with hints of drawing added – nothing specific but suggesting crumbling rock faces and rough growth. The roof of the cottage, the neighbouring barn, the tree and the skyline make one continuous hard edge across the upper part of the painting; elsewhere the edges are softer. Using Indigo, I painted the sky darker than it actually was in order to show up the house. The greens are mainly Hooker's Green, modified in places with a little Burnt Umber or Indigo.

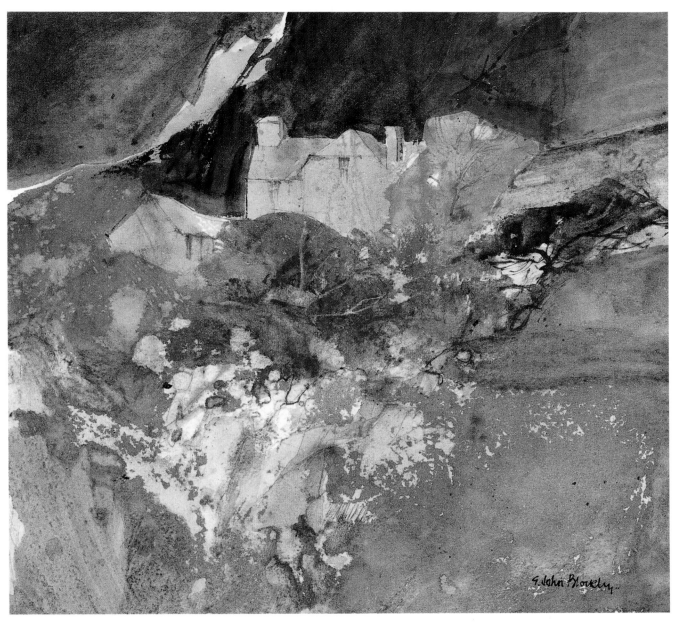

230 x 255 mm (9 x 10 in)

Strumble Farmhouse 2

Here I came in to get a closer look at the house. I liked the roof shape and so I again made it sharp and crisp, continuing this sharpness in the outline of the neighbouring building and the tree. This is the principal hard edge in the painting and again contrasts with the softer effect created by the washing-out process in the foreground. The profile of the mountain is sharp and edgy, too, with interesting 'cut out' shapes; it is located close to the building so that all the hard edges in the painting are concentrated in one area. As for the painting on the opposite page I used Indigo for the sky and Hooker's Green modified in places with Burnt Umber and Indigo for the green areas.

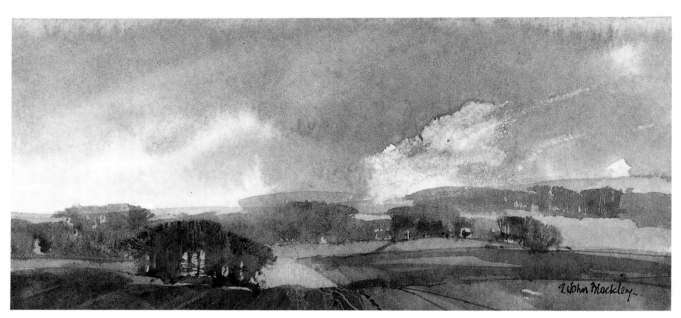

90 x 190 mm (3½ x 7½ in)

Cotswold Landscape 1

This is a fairly literal rendering of the
landscape but with emphasis on the field
patterns and the masses of trees. These
trees are seen as overlapping shapes and
are arranged to create a sense of
recession.

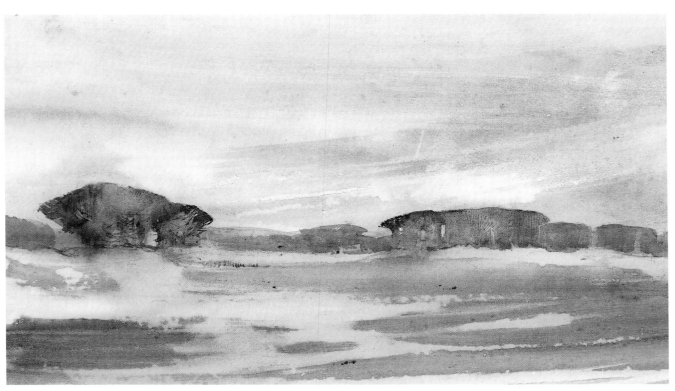

150 x 280 mm (6 x 11 in)

Cotswold Landscape 2
This interpretation of a Cotswold land-
scape is viewed from a lower level than
the previous one, with the result that the
distant hills are now hidden. I used very
wet washes for this painting.

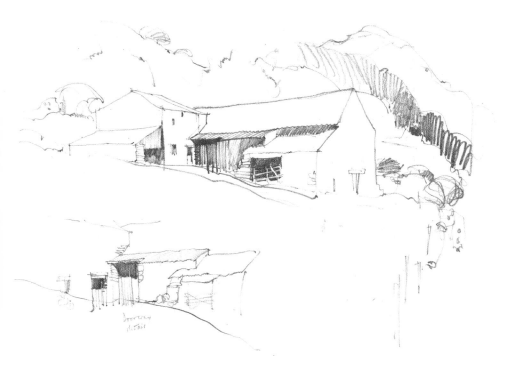

Lake District Barn 1 (*right*)
This painting of a farm near Broughton in the Lake District, based on the drawing on the left, is a fairly straight-forward record of the building and its surroundings except that I left out some fence posts and exaggerated the fore-ground boulders. There is quite a lot of precise linework in this painting, made with the edge of a painting knife dipped in watercolour.

I tried to paint the distant trees in sympathy with the colouring and feel of the building and I like to think that the edgy little blots of dark between the tree trunks echo, in a way, the dark details in the building.

For most of the painting I used Cadmium Red mixed with varying amounts of Indigo. The green was made by mixing Lemon Yellow with Indigo.

Pencil drawing, 290 x 380 mm (11/2 x 15 in)

Lake District Barn
This drawing was made on the spot with a 4B pencil. I was interested in the solid-looking bulk of the big stone-built build-ing and this is registered in the drawing by giving it a crisp, direct outline with each line correctly observed and drawn precisely. I was also attracted by the dark tones in the doorways and behind the gate so I blocked these in with passages of pencil shading. This use of taut pencil line in association with spontaneous, freer drawing gives life and sparkle to a drawing.

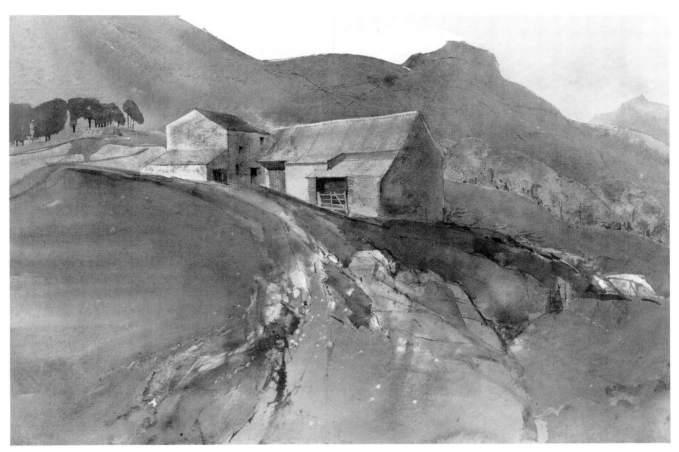

355 x 510 mm (14 x 20 in)

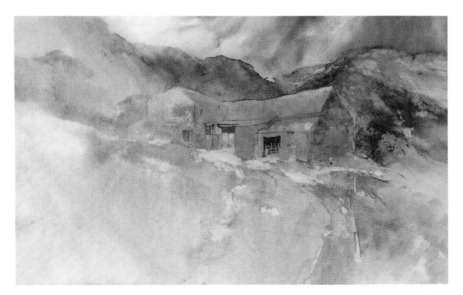

355 x 510 mm (14 x 20 in)

Lake District Barn 2

This interpretation is perhaps a little more imaginative – romantic? The building is painted less literally than in the previous painting, with parts of its colour blotted to give the effect of soft lighting. I have taken great liberties with the background and changed the profile of the mountain considerably. In retrospect, I don't understand why I did this for it seems quite unnecessary. I am especially puzzled because although I might feel free to remove a few fence posts, I would normally take great care in drawing the very definite profile of a mountain top like this.

I used mainly Phthalo Blue for the sky and mountain, and a little of this blue added to Aureolin for the building. The foreground was painted with dilute Raw Sienna with a little Cadmium Red.

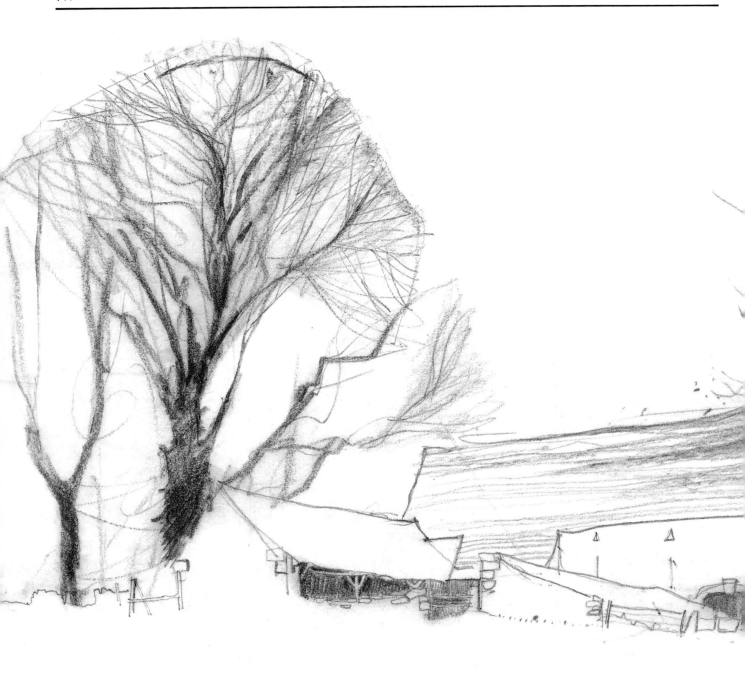

Gloucestershire **Barn**

I made this drawing, on site, in late
February. The trees were black,
dominant, and had interesting shapes,
with their curved tops almost looking as
though they had been trimmed to shape.
I used a soft, very black charcoal pencil
and sketched the trees quickly and
roughly, scribbling in the dark tones. This
treatment seemed consistent with the
coarse textures of the trees. In contrast,
the big stone barn was drawn with a
more precise line and little tone, so that
the blackness of the trees predominates.
The emptiness of the foreground provides
an area of light tone, repeated in the roof
of the smaller building. These white areas
give emphasis to the trees.

The period from February to March is
an exciting time for the painter. It hovers
between winter and spring, between
anger and calm. In making this drawing
I tried to suggest the spirit of February –
a favourite painting time for me. It's a
month of strong winds, with the black
tracery of trees set sometimes against
clear skies or more frequently against
deep pewter ones.

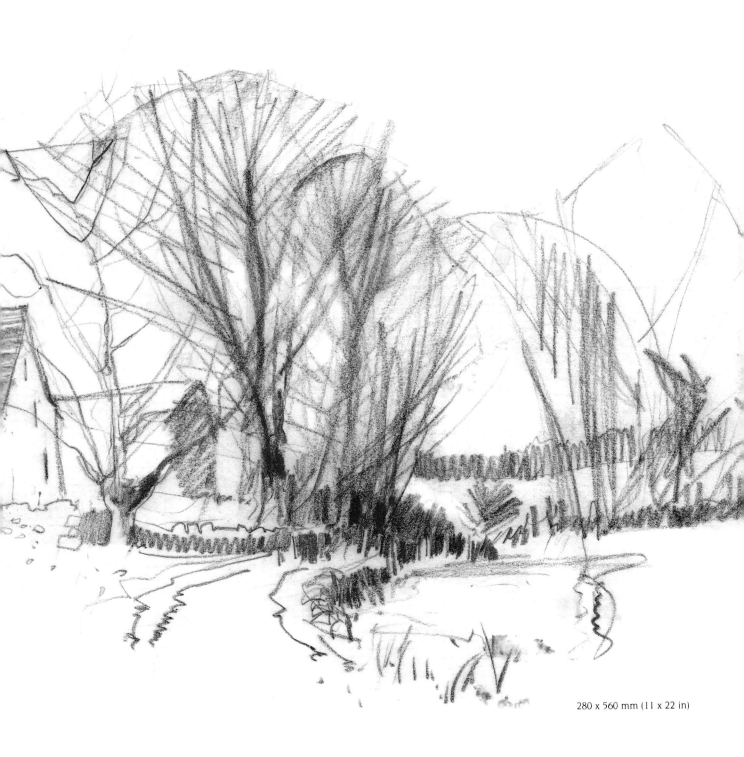

280 x 560 mm (11 x 22 in)

Farm on Dartmoor

This drawing, made on site in Devon,
contains positive linework. Such direct-
ness of working seems in keeping with
the strength and solidity of the farm
buildings. The drawing was done quickly
but nevertheless it registers the impor-
tant characteristics and shapes of the
subject. The buildings were drawn deci-
sively to reveal their functional shape,
whereas the trees were put in lightly and
freely to suggest the movement and
slenderness of the branches. The bounda-
ry walls in this part of Britain are made
with big random-shaped stones and
boulders, some rounded, some angular. I
indicated the character of these walls with
minimal, almost aggressive drawing.

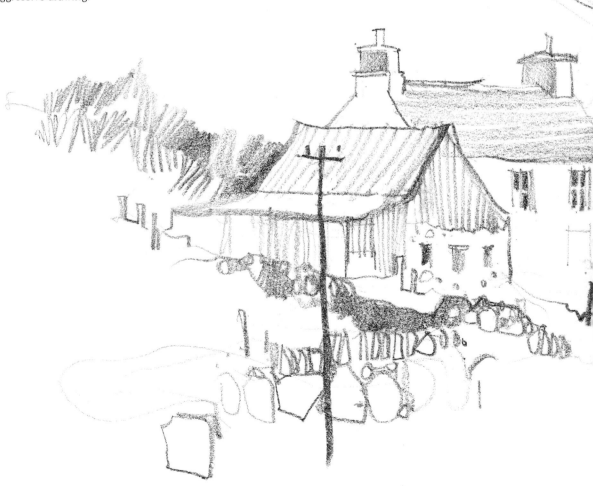

Charcoal pencil drawing, 405 x 560 mm (16 x 22 in)

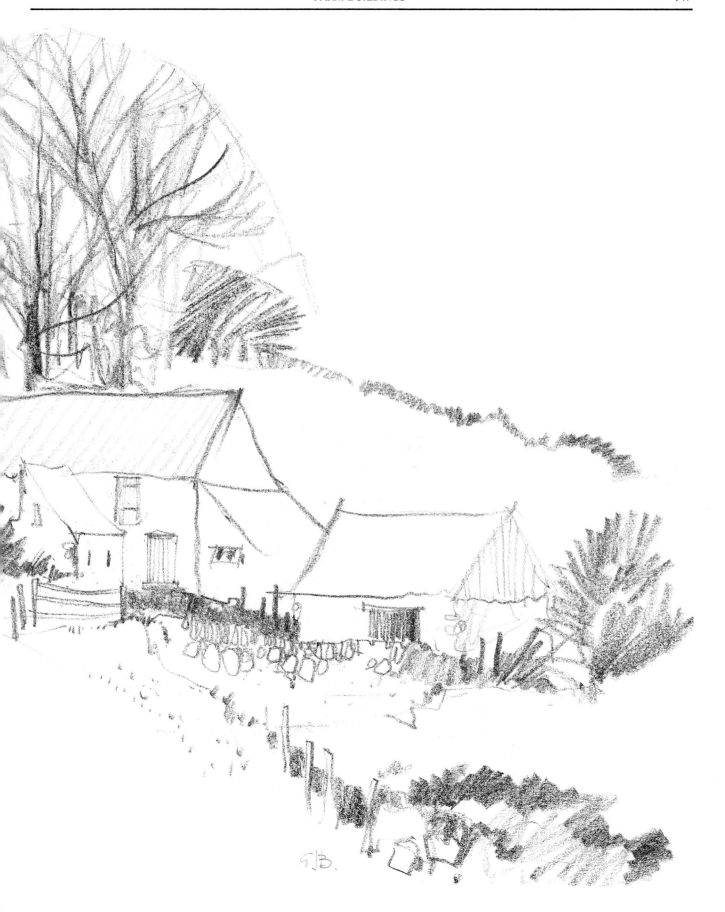

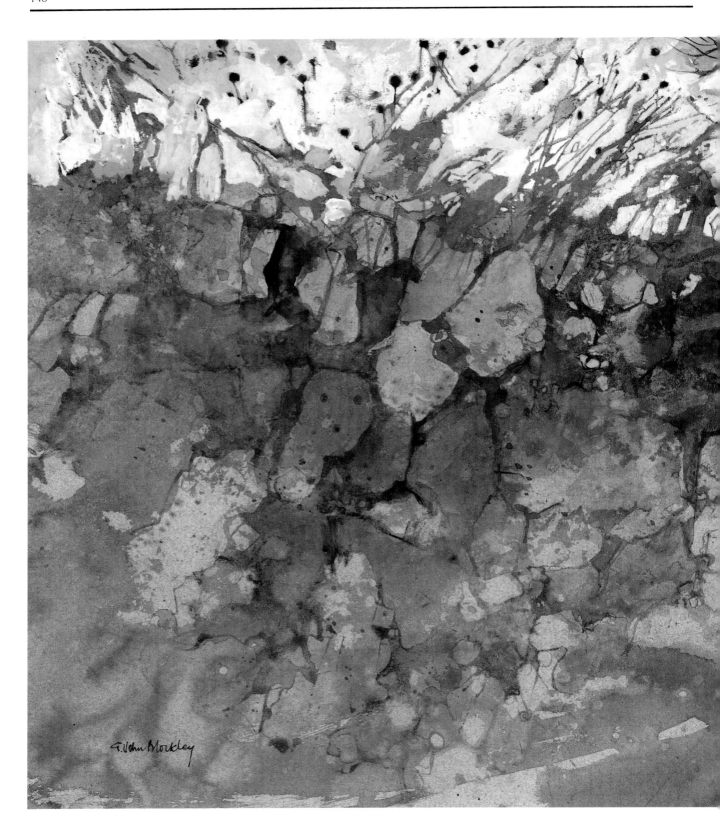

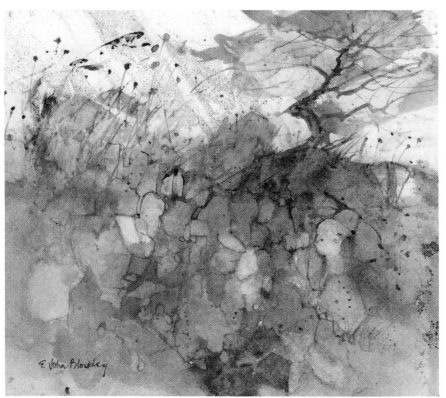

180 x 205 mm (7 x 8 in)

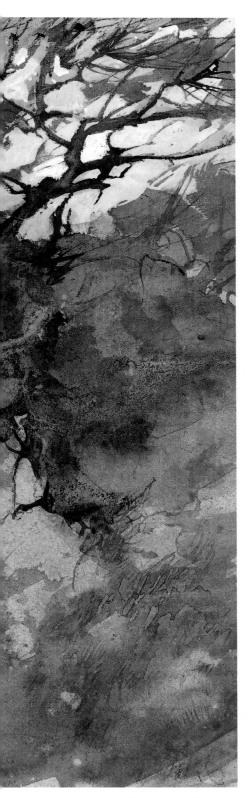

305 x 380 mm (12 x 15 in)

Dartmoor Wall 1 (left)

This is a close-up painting of a typical wall on Dartmoor in Devon, such as indicated in my drawing of a Dartmoor farm (pages 146–7). These walls are built by fitting stones together and packing the spaces in between with soil. Most were built years ago so now plants grow in the crevices and lichen grows on the eroded stone surfaces. There is one major difference in the way this is painted compared with the other paintings in this book: it is done on grey paper. This can be seen in some of the pale stones.

I was especially attracted to the long grasses with their seed pods growing on top of the wall. Instead of drawing the grass stalks carefully with a fine brush, I scrubbed the dark paint over the sky area, then overpainted this with white gouache, leaving lines of the dark paint showing to represent the grass stalks. The rest of the wall was painted by brushing Hooker's Green and Indigo over the paper and then washing out areas to suggest the lighter stones, defining their edges occasionally with the end of the brush handle dipped in paint.

Dartmoor Wall 2 (above)

This little study was painted on white Hot-pressed paper. This has a very smooth surface and is helpful in obtaining subtle nuances of colour, which sometimes produce an almost marbled effect. I used the washing-out process and included some drawing done with the brush handle dipped in paint. As for the previous painting I used Hooker's Green and Indigo.

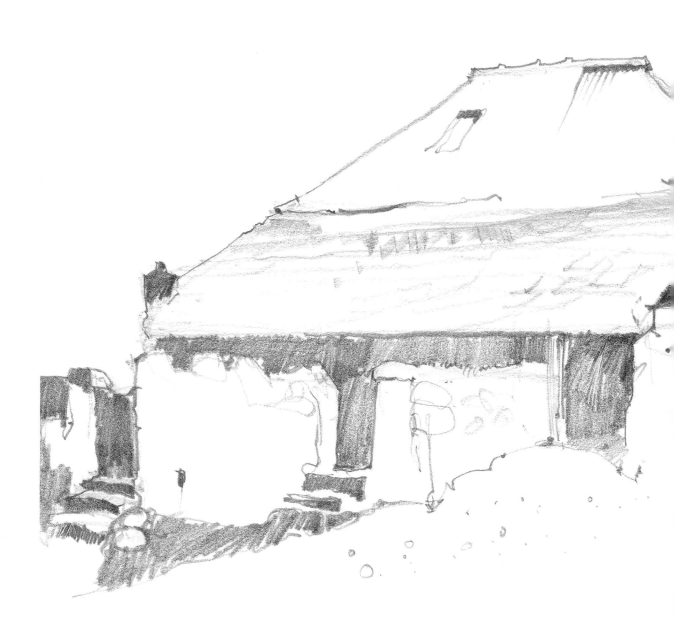

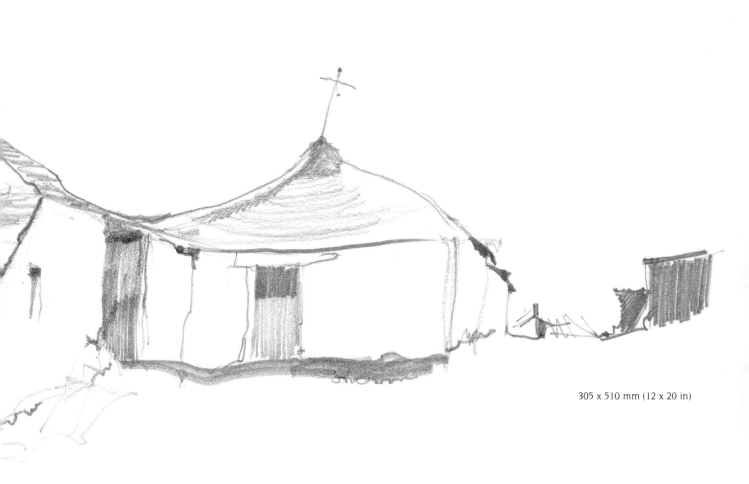

305 x 510 mm (12 x 20 in)

Pembrokeshire Farm Buildings

The walls of these old buildings in South Wales are made of stone and painted brilliant white. The roofs are partly tiled, repaired in places with corrugated asbestos, but mostly they are rendered with cement which has smoothed out their contours. This is seen especially in the building on the right where the convoluted roof sweeps downwards in gentle curves. The cement was applied quite smoothly but then it was brushed with a stiff-bristled broom which scored it into circular patterns. I am looking forward to making a painting of this and to re-creating these brush marks in the roof. I can imagine the sky as a flat wash of Cobalt Blue, setting off the clean and fresh whiteness of the stone walls, while the textured patterns are confined to the roof of the building.

125 x 205 mm (5 x 8 in)

Soft Morning

This painting depicts a gentle morning scene with hints of distant landscape. The sky is the most important part of the painting with soft cloud drifting diagonally across it, and flecks of scattered light below.

The tonal values here are important, especially in the vague distant trees and the nearer mass of trees, all of which are tonally judged to suggest recession. These trees are hard-edged at the top but are prevented from being overdominant by the tonal judgement; they remain secondary to the sky. The colouring of the foreground – Burnt Sienna slightly subdued with Indigo – was chosen to emphasize the blueness of the sky. The diagonal movement within the foreground grasses provides a little activity and life within the overall softness of the painting, but I was careful not to overstate this because strong diagonal lines can be aggressive and would have destroyed the theme of this painting.

180 x 365 mm (7 x 14½ in)

Storm Clouds

The idea behind this painting was to suggest ominous storm clouds with brilliant light breaking through them. Because, therefore, my main interest was in the sky, the landscape has no particularly strong features and consists only of a soft-edged band of Olive Green and some Cadmium Orange. However, an element of sparkle was introduced, reflecting the white bits of cloud, by washing out some passages of light.

I used Indigo for the sky, with a little Phthalo Blue, and painted with a fully charged brush dragged sideways over the paper. By using this technique the paper is left white in parts, whereas the blue wash is sharp in others and elsewhere melts wet into wet to give softly diffused edges to the cloud formations. The whitest part of the sky and the sharpest edges are contained in the left side of the painting.

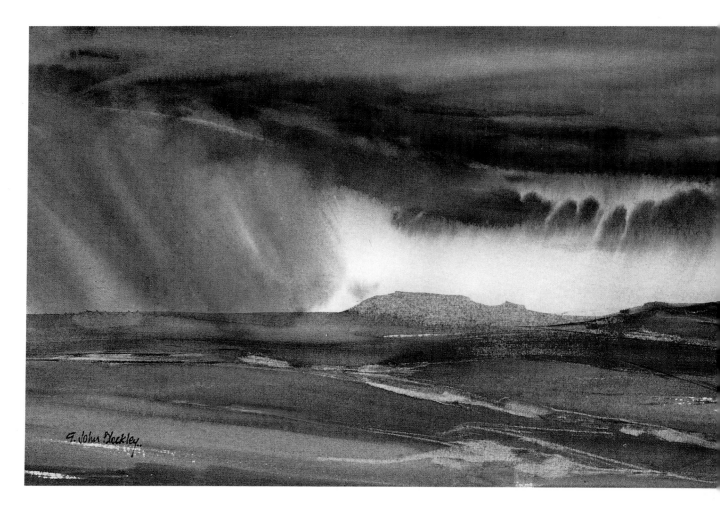

Caithness Sky

This was painted on the spot one evening. The dark hill shapes against the light caught my eye. Often when rain is falling in the distance the light in the sky seems intensified. I reckoned I hadn't much time to paint, with the storm clouds approaching me, so I rested my paper on the car and worked quickly and vigorously.

In this interpretation the light in the sky is emphasized by contrasting it with the dark hills. This effect is increased by giving the hills a hard-edged profile. Also, by making this the only hard edge in the painting the eye is drawn to it.

I began by painting the sky, wetting the paper first with clean water then working a brush fully charged with Indigo into it. The brush strokes bled downwards into the wet paper to create an atmospheric effect. When the paper was dry, I registered the deep Ultramarine hills, hard and edgy against the sky, then continued the wash downwards, adding Burnt Umber and Hooker's Green. Finally, I lifted out soft-edged passages within the ground area with a damp brush.

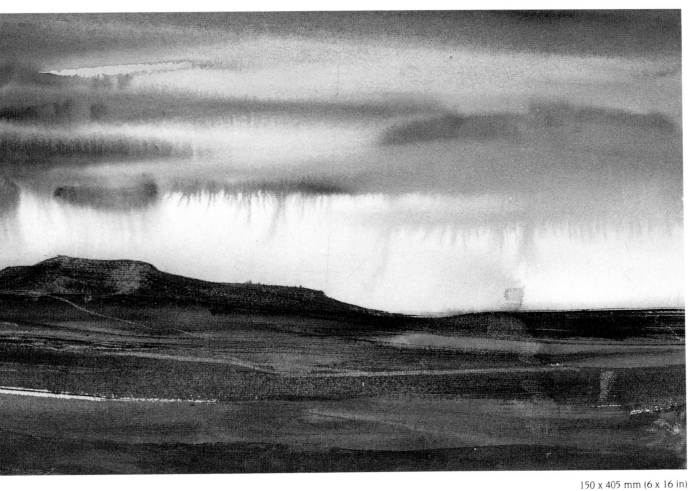

150 x 405 mm (6 x 16 in)

G. John Blockley.

Moorland Road 1

I arranged this painting, appropriately entitled *End of the Road*, in terms of three horizontal bands, with a vertical movement cutting upwards through them to the skyline. I thought that this point should be emphasized in some way – but not too obviously so, not with a house or any definite feature – and therefore I merely spread a narrow strip of light outwards from the road along the skyline. This is echoed by a smaller strip just where the road disappears over the edge in the foreground.

The position of the moon was carefully judged to attract the eye along the road towards the skyline. To paint it I lifted a disc of colour from the still-damp sky wash with a moist brush, then added a little Lemon Yellow. I left some white paper within the moon, however, to provide a link with the skyline band of light and the road.

All edges in the painting are relatively soft, achieved by working wet into wet and by lifting and washing out colour. I used Burnt Umber mixed with Indigo for the middle distance and very dilute Indigo mixed with Lemon Yellow for the foreground.

255 x 355 mm (10 x 14 in)

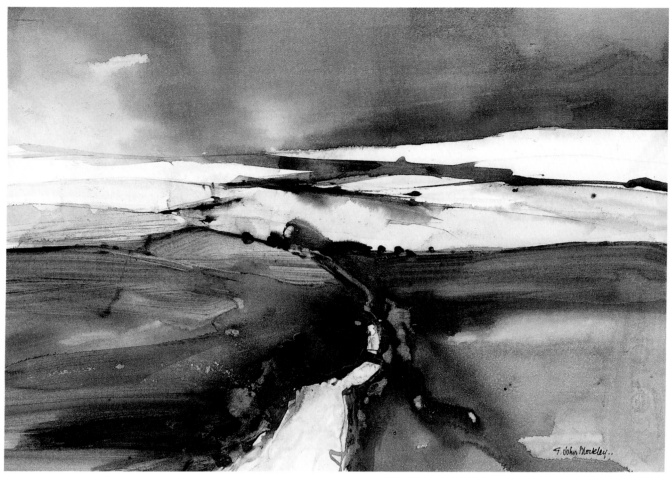

255 x 355 mm (10 x 14 in)

Moorland Road 2

Here I kept to the same idea of dividing the picture into three horizontal bands bisected by a vertical movement threading upwards towards the sky, but this time I reversed the tonal pattern: the foreground is dark and the distance pale.

As in the previous painting my purpose is again to attract the viewer upwards through the painting. I achieve this here by placing the strongest contrast in the distance: the whiteness of the snow and the dark zigzag pattern form hard-edged shapes which slice across the paper and so attract the eye. In contrast, the tones within the sky and the foreground are soft and moody. In addition, the drama of the whiteness in the distance is intensified by keeping it narrow and sandwiched between the dark layers of sky and foreground.

The small area of light road in the foreground provides a kind of balancing echo within the design. Notice that where the road tapers away it is crossed by a narrow band of dark. This is a pattern device, to echo the distant dark zigzag shape. Small incidents such as this create secondary interests within a composition.

Most of the painting was done with Indigo and a little Black, with Aureolin mixed with Black to make the green used for the foreground.

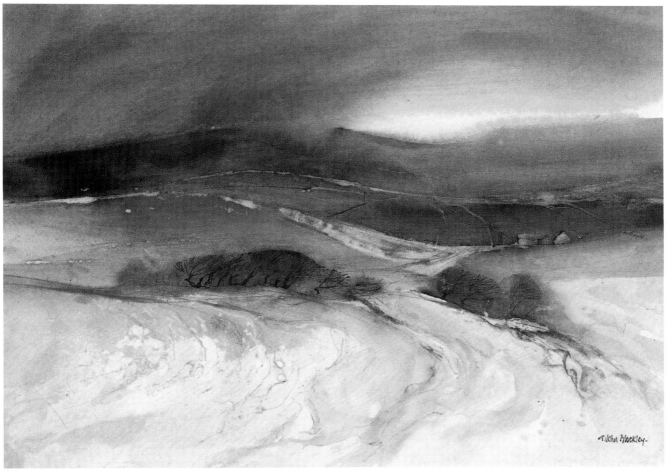

255 x 355 mm (10 x 14 in)

Moorland Road 3

Here the three bands of sky, moorland and foreground are less obvious. The shapes of the three elements are not as precise as in the other paintings; they taper and curve. The tonal pattern is less defined, too, especially when compared with the definite black and white bands of the previous interpretation. All the edges are soft and the whole sense of the painting is atmospheric.

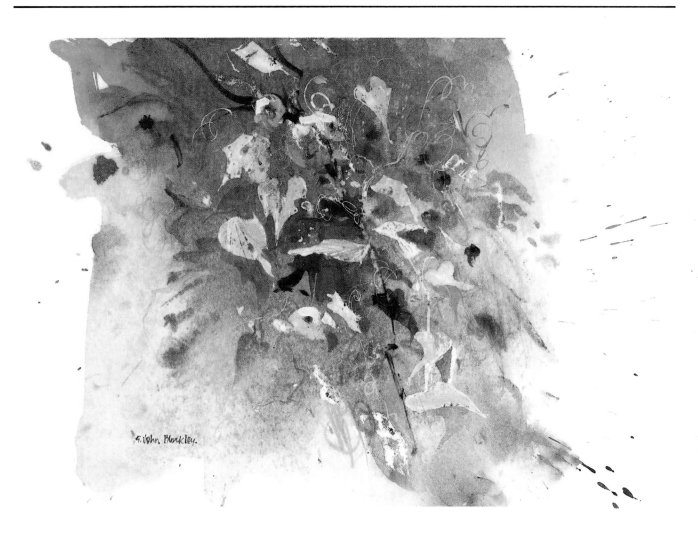

Roadside Weeds
205 x 230 mm (8 x 9 in)